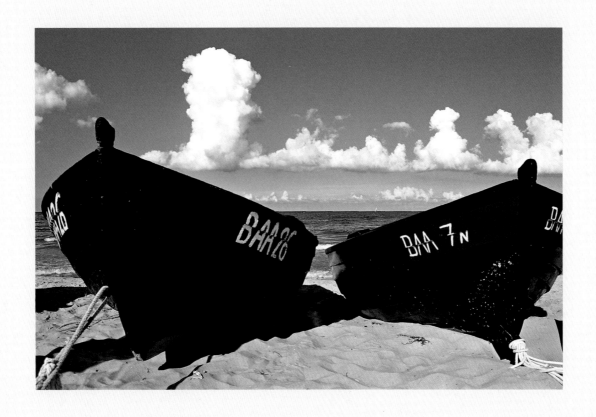

Journey through

MECKLENBURG-
WESTERN POMERANIA

Photos by
Tina and Horst Herzig

Text by
Ernst-Otto Luthardt

Stürtz

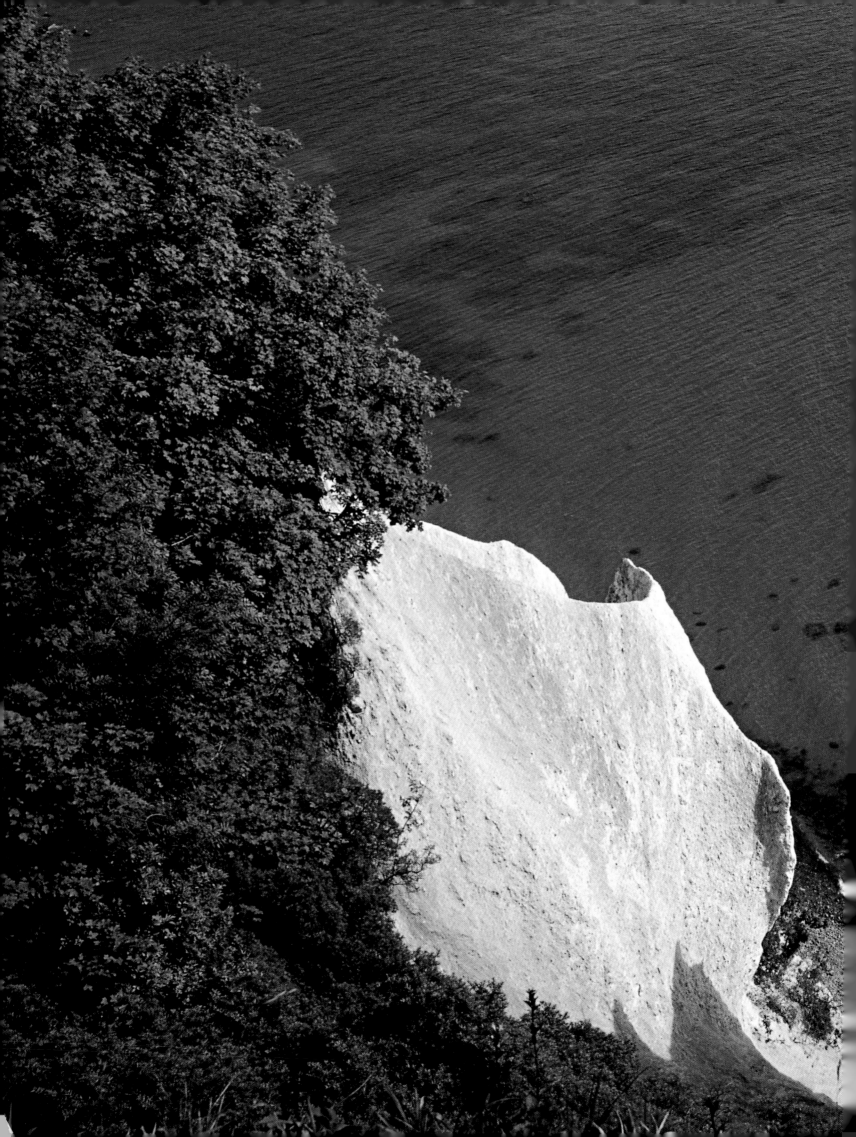

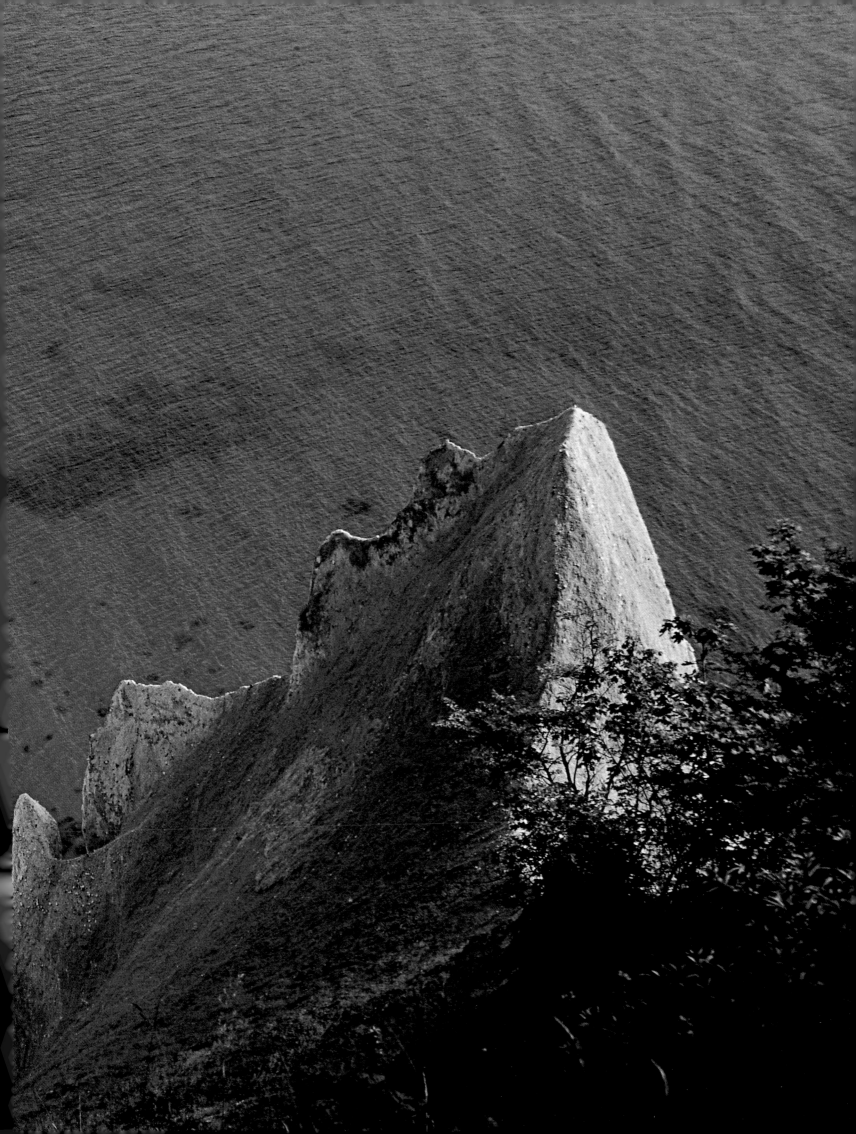

First page:
Fishing boats on the beach at Baabe. In 1905, the small town caused a sensation when ladies and gentlemen were permitted to swim

together here for the first time on Rügen. Today, Baabe with its beautiful sandy beach is a great place for anyone looking for peace and quiet.

Previous page:
This is something you will sadly no longer see when you travel to Mecklenburg-Western Pomerania. On February 24, 2005, two

sizeable sections of cliff crumbled off the Wissower Klinken and crashed into the sea. The famous peaks now look very different.

Below:
Today, the former abbey of St Catharine in Stralsund, which housed the Provincial Museum of New Western Pomerania and Rügen from 1858, is the home of the

German Marine Museum. Large parts of the well-preserved building originated in the 15th century and belonged to the Dominican order until the Reformation.

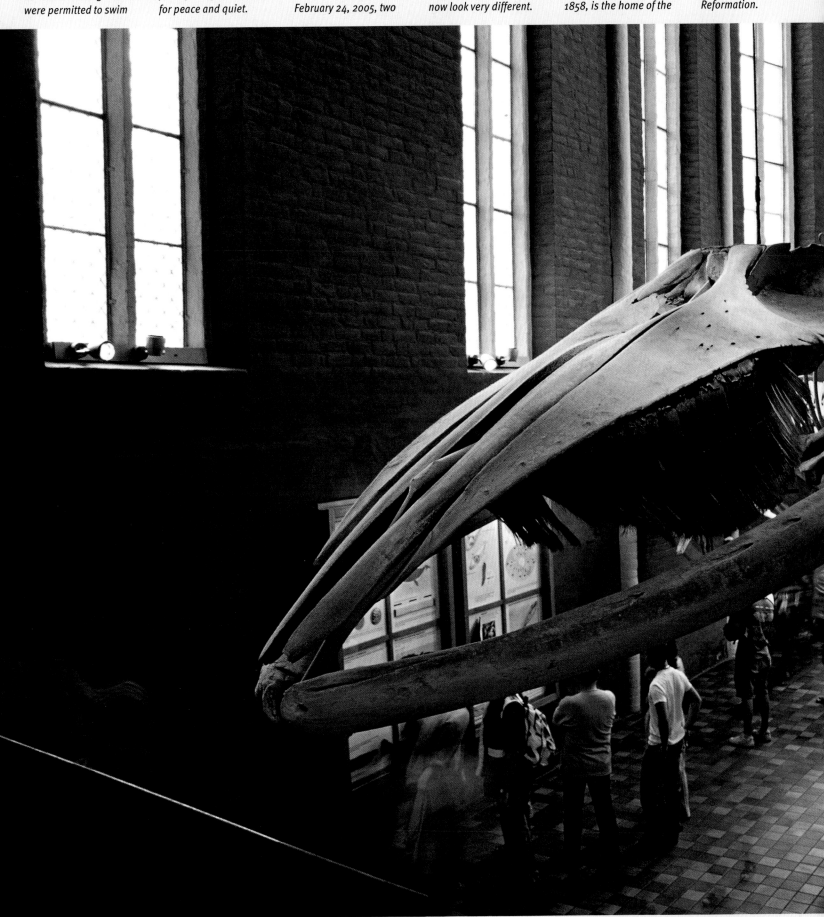

Pages 10/11:
A view of the harbour
at the Baltic Sea resort
Wustrow. Situated
between the Baltic and
Bodden, the oldest
settlement on Fischland

has a long seafaring
tradition. Good reason to
found the "Navigational
School of the Grand Duchy
of Mecklenburg" here in
1846, which existed for
nearly 150 years.

Contents

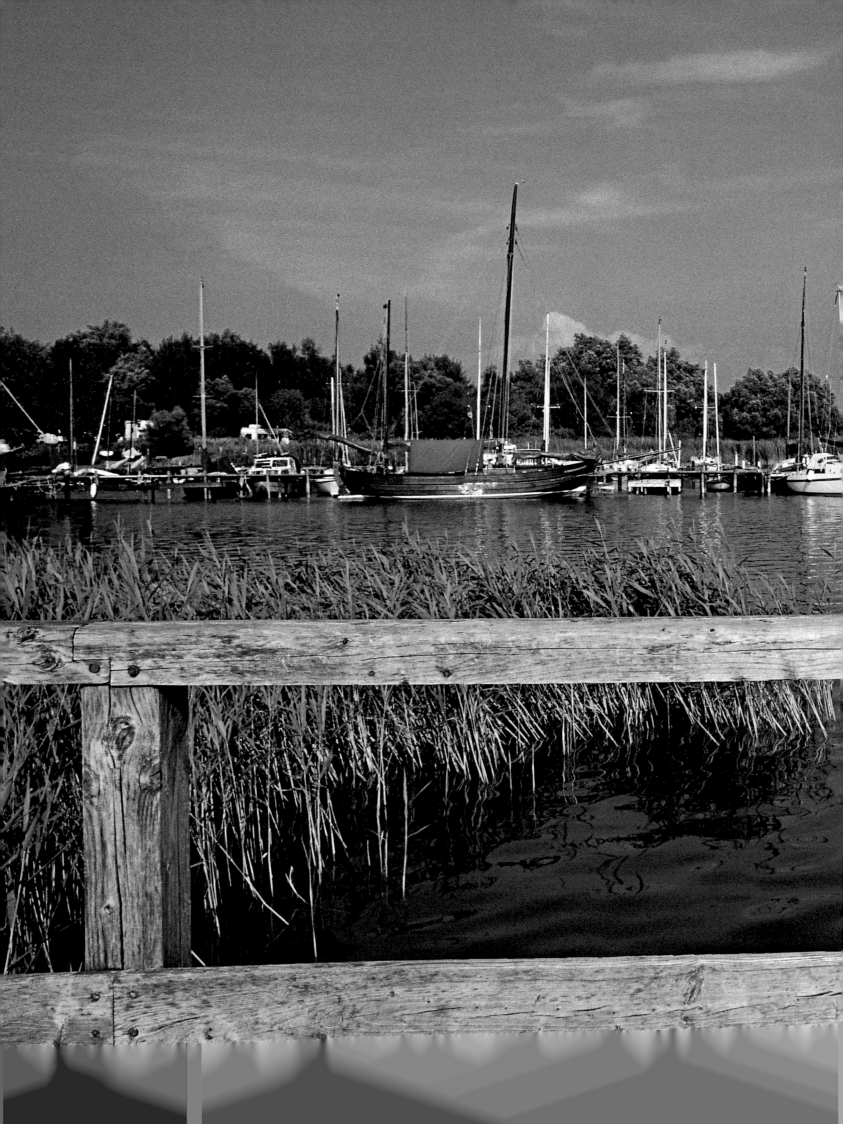

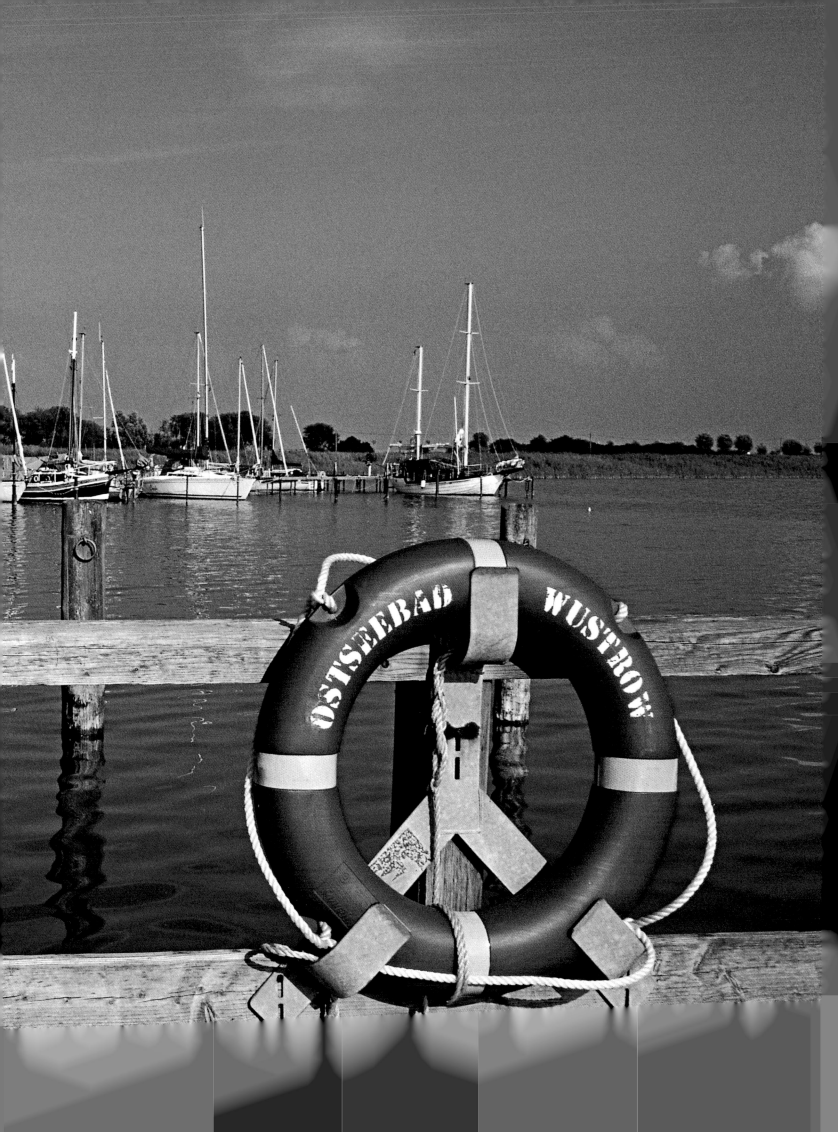

Embraced by water –
Mecklenburg-Western Pomerania

Meckelburg stretches alongside the Mare Balthico, bordering towards the Orient with Pomerania, towards the Occident it channels the Elbe, which at midday lies in the Marck Brandenburg and at midnight in the Balthic Sea", we read on a map dating from the early 17th century. Since then, much time has passed. The modern federal state ranges not only over the original territory of old Mecklenburg, but, as its name denotes, encompasses the German parts of Western Pomerania as well. A piece of the Mark Brandenburg was also added. All in all, 23,172 square kilometres (8,947 square miles) with not quite 1.8 million inhabitants: nowhere else in Germany is there more space for each of them than here.

Even in the summertime, when crowds of vacationers take over the beaches of the Baltic Sea and the Mecklenburg Lakeland, there is still more than enough space and plenty of opportunity to escape the hubbub and get close to nature. In earlier days, the region's rural character may have been pitied or mocked, but today that character is one of its greatest charms. Only Rostock, with its 200,000 inhabitants, can be called a big city. Schwerin, the state capital, is stretching to reach the 100,000 limit required for that description. One third of the population lives in villages of no more than 2,000 souls. The economic pillars are correspondingly slim. Moreover, both of them, the agricultural industry and the coastal shipyards, began to crumble after reunification. By contrast, tourism is recording growth figures. There are twice as many guests as residents, due to the fact that the well-known and admired

natural resources are complemented by an infrastructure that leaves nothing to be desired with regard to accommodation, recreational activities and wellness.

Carved by glaciers

The features of today's Mecklenburg landscape were formed by Ice Age glaciers. While the striations and depressions filled with meltwater, the terminal moraines solidified over time to form the "mountains" of the Baltic ridge, which blocked the outward flow of water. This constellation resulted in the birth of the Mecklenburg Lakeland. The centrepiece of this fascinating water world in the south of the state is Lake Müritz. In his day, the famous novelist and journalist Theodor Fontane had his heart set on marketing it for tourism. His efforts to entice Berlin holidaymakers to this "magnificent bit of earth" were based on a line of reasoning that still applies today: "The Müritz", he attested, "is something like a sea. ... The air is wonderful, depending on how the wind blows: a moist sea breeze or the fragrance of fir trees".

Today, not only people from the capital city, but many visitors from all of Germany and increasingly from other countries are discovering this romantic watery landscape. The main starting point is Waren on the northern shore of the Müritz. The completion of the new marina in particular turned the prettily decked-out town into the favourite address of marine sport enthusiasts. Another attraction beckons right at its front door: Müritz National Park. It encompasses more than 300 square kilometres (116 square miles) and is traversed by a network of hiking and cycling trails. If you keep your eyes open and have a bit of luck, you might even see one of the rare sea eagles circling in the skies. The huge birds, only recently threatened with extinction, feel so much at home here that their numbers are increasing.

Barrows

About 4,500 years ago, during the Stone Age, huge megalithic tombs were built in Mecklenburg-Western Pomerania. The mystery of how the often hundredweight erratic blocks were transported and set up fostered legends of giants. Who but giants could have lugged these huge stones about, set them up vertically in rows and then covered them with massive roof plates? Thus, the structures were given the name "Hünengräber", meaning "tombs of giants".
At the beginning of the 19th century, 236 of these by far oldest of monuments in northern and central Europe still stood on the island of Rügen. Fear of the giants then dissipated as the

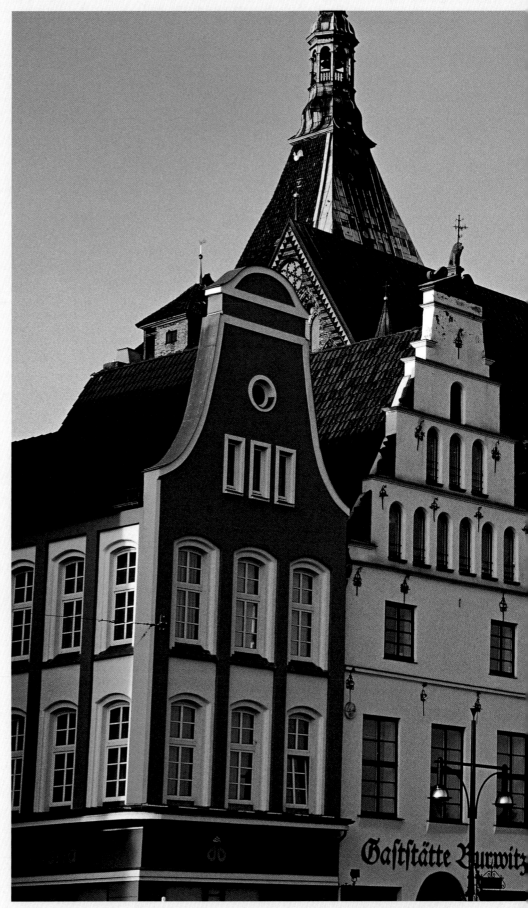

economic aspect of their supposed legacy was discovered – the gravestones were pilfered for use as paving and building stones.

The giants are no longer among us, but approximately 450 of originally more than 1,100 late Stone Age burial sites have survived in Mecklenburg-Western Pomerania, including 54 megalithic graves on Rügen alone. They are especially numerous and close together between the towns of Putbus and Lancken-Granitz. The fact that the Stone Age people favoured the island in this respect – similarly impressive burial sites from this time can be found on the mainland only near Grevesmühlen – was indubitably due to the material, as such large numbers of erratic blocks are found only here.

Near the end of the late Stone Age, the large graves were replaced by individual tombs. They remained characteristic of the epoch 1,800 years before the birth of Christ during which humans discovered the making of metals. The Bronze Age tombs were no longer built of stone, but of banked earth – making them easily mistaken for moraine tops or dunes. The best known of these grave mounds are the so-called "King's Grave" of Seddin near Perleberg on the mainland and those on the isle of Rügen – nine of them near Samten – and the Dobberworth near Sagard with a circumference of roughly 50 metres (165 feet) that towers high above its surroundings.

Teutons, Slavs and Hanseatics

The territory of today's Mecklenburg-Western Pomerania was first settled by Teutonic tribes, who were followed during the migration of peoples by Slavs. They founded the "castrum michelenburg" south of Wismar, which gave the region its name.

After Henry the Lion defeated the Obodrite prince Niklot around 1150 and appointed Niklot's Christianized son Przybyslaw as his vassal, eastern colonization began in full swing. German monks established monasteries

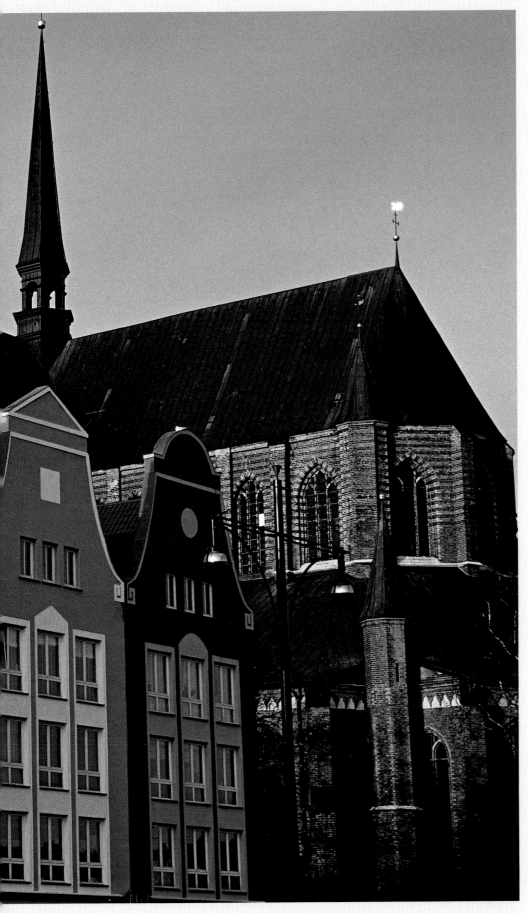

and German settlers founded cities. Although Emperor Charles IV raised the Mecklenburg princes to the status of dukes, and one of them even acquired the royal crown of Sweden for a short time, they soon had a powerful counterweight in the growing Hanseatic League. The Mecklenburg and Pomeranian cities created an alliance with the leading power of Lübeck and drew their profits from military dominance over the Baltic Sea and the trade monopoly on the Nordic seas.

During this golden age of urban development, magnificent churches and imposing city halls and homes were erected in typical red brick. Besides Wismar, Rostock was the most important harbour in Mecklenburg. In 1419, northern Europe's first university opened its doors here. The huge Jakobikirche is yet another superstructure of the city, whose nave of 37 metres (121 feet) reaches closer to the heavens than most churches in Germany.

Wallenstein becomes duke

The Thirty Years' War brought an end not only to the glorious Hanseatic Age, but also to the prevailing dynastic circumstances. In the place of princes residing in Schwerin and Güstrow, over whom the emperor imposed the imperial ban, a "newcomer" gained his way to power: in 1628, Wallenstein was named Duke of Mecklenburg. Dissatisfied with his new properties, he gave them a quick shake up. Most importantly, he replaced the nobility and the court classes with efficient civil servants. He furthermore dedicated himself to the well-being of his subjects. The warrior Wallenstein not only attempted to keep his holdings out of the battles, but also dreamed of transforming them into a "terra felix" – an "island of happiness". One of the measures implemented for this purpose was to oblige all cities and parishes to set up an almshouse or hospital within the space of six months – a feat that earns as much merit as his feats on diverse battlefields.

Western Pomeranian intermezzo

In Pomerania, which was not re-conquered by the sword but converted by the missionary labours of Bishop Otto of Bamberg, Stralsund claimed the leading position during the Hanseatic Age. So it was no coincidence that the Danish king signed a treaty in the Stralsund Town Hall in 1370, by which the alliance of cities was granted voting rights in the throne succession and which helped it rise to become the undisputed ruler of the Baltic and North Seas. The city still reaps profits from this past. The Old Market, in particular, has a

number of pearls of brick Gothic architecture strung along it including the showpiece "Rathaus" (Town Hall), the Wulflam House and the Nikolaikirche. In the side streets, many a ruin has recently been transformed back into an architectural jewel.

The former settlement of "Grypeswold", which originated from 1199 next to the Cistercian monastery of Eldena and received a town charter in 1250 and a university in 1456, has similarly imposing sights to offer. The distinctive architectural landmarks of the Hanseatic city of Greifswald are the three monumental brick churches dedicated to St Mary, St Nicolas and St James.

The Thirty Years' War laid waste to both Mecklenburg and Pomerania. It must have raged here with exceptional ferocity, or the memory would not have lived on so long in the well-known nursery rhyme:

Maikäfer flieg!
Der Vater ist im Krieg.
Die Mutter ist in Pommerland,
Pommerland ist abgebrannt.
Maikäfer flieg!

Maybug, fly!
Your father's gone to war.
Your mother is in Pommerland,
Pommerland's burnt to the ground.
Maybug, fly!

In 1637, in the middle of the war, the old ruling house of the Greif princes died out. This led to the land being divided up between Brandenburg and Sweden by the Peace of Westphalia. Sweden received Western Pomerania and Rügen. The Prussians were only able to "repurchase" them in instalments. In 1725, King Frederick William I added the eastern part of Western Pomerania to his properties, and then in 1815, as a consequence of the Vienna Congress, the

remainder, called "New Western Pomerania", around Stralsund, Demmin and Greifswald was added along with Rügen.

The flower and the queen

The scene is London in the early 18th century. The court gardener of the English royal house bred a flower of striking appearance. It had an overlong stem ending in a large, beaklike blossom of oranges and blues. As was fitting for a loyal subject, the man named his strain after His Majesty's spouse. Her name was Charlotte and she was the sister of Grand Duke Adolf-Frederick IV of Mecklenburg-Strelitz, who ruled the smaller of the two parts of Mecklenburg, created by the Treaty of Hamburg of 1701 and existing until 1918. The new flower was not christened with the name, but with the birthplace of the queen: Strelitz became Strelitzia.

The palatial residence of Neustrelitz is not much older than the flower. It was built in 1733. Although it was reduced to rubble in 1945, the palace gardens were preserved. Originally laid out in the Baroque style and later transformed into an English garden, it counts among the most significant historic parks of northern Germany. The Luisentempel, dating from 1892, upholds the memory of beloved Prussian Queen Louise, whose beauty, grace, intelligence and social commitment won the hearts of the people. She was the utter opposite of her spouse Frederick William III of Prussia, who was deserving of anything but devotion both as king and as man. Louise lived only 34 years. At her place of death, the palace of Hohenzieritz north of Neustrelitz, a memorial keeps the memory of this exceptional queen alive, while the Palace Garden Festival in Neustrelitz resurrects her every year on the operetta stage. The stage is also a central element of life in Putbus on Rügen – and has been since 1821. The lovely theatre, which still has most of the original fittings, is one of the architectural jewels built by Count Wilhelm Malte I of Putbus to commemorate his elevation to prince. It took the art-loving ruler 15 years to reconstruct his old family seat to a residence befitting his status and to group around it an entire ensemble of neoclassical buildings. Encircled by a good dozen glowing white buildings, the large circular plaza called the "Circus" is adorned only by trees and a central obelisk. Then, as today, the Circus was the hub of that small world with the cultural claim to fame of being one of the last planned royal cities. It's a pity that the palace was demolished during GDR times.

17

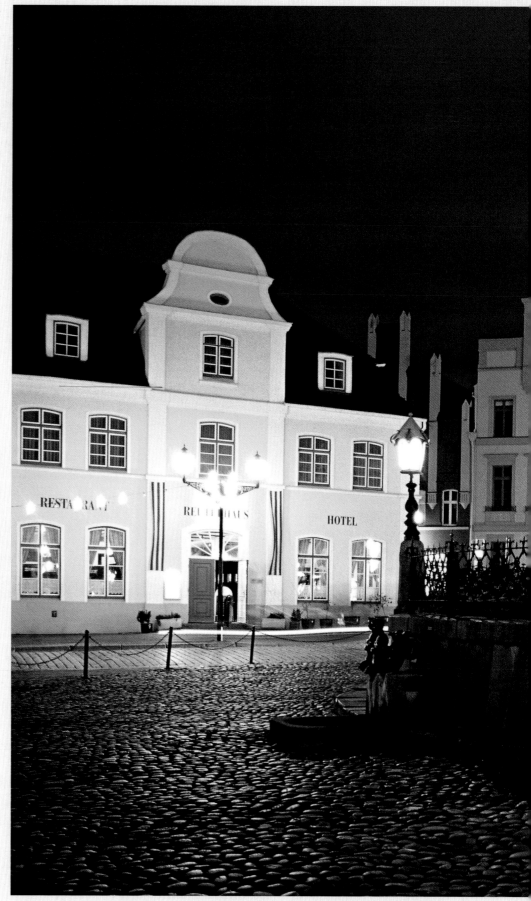

In the state capital

For about 500 years, the Mecklenburg dukes governed their land from Schwerin. This explains how the city was able to beat considerably larger Rostock when straws were drawn to choose the future capital city of Mecklenburg-Western Pomerania. In 2010, Schwerin will celebrate its 850th birthday, but the bright birthday bouquet will arrive a year earlier, when the Federal Garden Show is held here. This will encompass not only the castle and palace gardens and newly created park areas, but also include all of the surrounding waters. The cityscape is dominated by the cathedral and the castle, which was built in the 16th century atop the site of an old Slavic fortress. Given a good "facelift" in the mid-19th century, the castle today presents itself as a romantic fairy-tale structure, modelled on Chateau Chambord on the Loire. It is the domicile not only of the state parliament, but also of a teasing, yet inherently good-natured castle ghost called the "Petermännchen" (little man Peter) – but he has not been seen for a long time. As his name denotes, he is said to be of small stature and wears bucket-top boots and a floppy hat. The colour of his clothing is significant – red is a good sign, while black signifies disaster. It is said that he appeared to Wallenstein, among others, yet we do not know which colour his suit was at the time.

Neither has it been passed down whether the poltergeist was behind the fateful move when Duke Friedrich felt compelled to leave Schwerin for greener grasses. Near the town of Klenow, his father, Duke Christian Ludwig II, had a hunting lodge, which Friedrich renovated until 1780 to convert it into a "Versailles en miniature". Although the size is more suited for Mecklenburg, and a major share of the décor is more show than substance (it was made of papier-mâché manufactured in a factory spe-

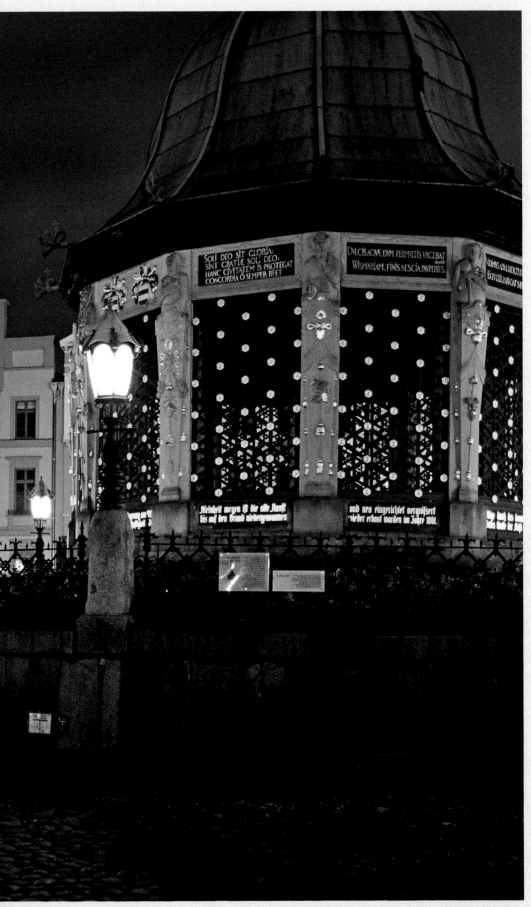

cially erected for the purpose), it is a palace well worth visiting. The palace garden, with its Baroque fountains and varied architectural décor is not only the largest, but also the fairest in the land.

Conquerors of the sky

With his brother Gustav, Otto Lilienthal (born in 1848 in Anklam, Western Pomerania) dared to take to the skies as Icarus of old. His teachers were the storks of the river Peene, and by observing them, he came to the original realization that "all flight is based upon producing air pressure; all flight energy consists in overcoming air pressure". The first practical experiments made to test this hypothesis were mere leaps into the wind and cannot be called flying. The brothers' hopping and jumping was not only comical, but also painful; nevertheless neither sprained nor broken limbs could put a stop to their dream of flying.

On a fateful day in 1891, Lilienthal glided an entire 250 metres (820 feet), proving that humans could emulate the birds. In the end, he paid a high price for this knowledge. In 1896, while testing his glider number 7, he met the same fate as his legendary predecessor Icarus and fell to his death.

Precisely four decades later, the Peene River would become a major scene of military conquest over the skies. At the army testing facilities set up near the fishing village of Peenemünde, German scientists built the first rockets. They were intended as "Wunderweapons" to prevent the defeat of Nazi Germany – as we now know in vain. Unlike Icarus and Lilienthal, however, the researchers survived their "fall" unharmed. A good many of them – including Wernher von Braun – began a second successful career under new masters.

Atlantis of the north

In the day of the historian and geographer Adam of Bremen (died c. 1076) Vineta, populated by Slavs and other peoples, was "the largest of all cities within Europe" and the "most highly visited centre of transit for the Barbarians and Greeks in the vicinity". Only one hundred years later, Helmold of Bosau wrote the city's obituary in his "Chronicle of the Slavs". The godless and immoral city had been swallowed by the waves of the Baltic Sea. Around 1345, Brother Angelus of Stargard gave the world the "Vineta Saga", which fascinates patriotic local historians and treasure seekers as well as historians and archaeologists even today.

Since Adam of Bremen clearly stated that the city was located at the mouth of the Oder, the search for Vineta focuses on Usedom and Wollin. On the latter island, today in Poland, the remains of a large trading city have actually been dug up. Only a kilometre (half a mile) from the coast of Usedom the remains of the "Vineta riff", feared by seafarers and therefore removed in the early 19th century, refer to the sunken city.

Wherever it may have been, probably only one person ever saw the sunken city again: little Nils Holgersson in the books by Selma Lagerlöf. Carried by Master Ermenrich, the stork, to Pomerania, Nils takes a stroll on the beach, where he suddenly sees a city arise from the sea and later disappear again just as mysteriously. Clever Master Ermenrich informs him that Vineta reveals itself every 100 years and then only one hour is granted to redeem the city and its populace from their fate. Those who do not wish to wait that long can journey to Zinnowitz or Barth, where the Vineta saga is the subject of colourful staged spectacles all summer long.

Beaches, beaches, beaches

If it weren't for the bays, inlets, sandbars and islands, the coast of Mecklenburg-Western Pomerania would be "only" about 350 kilometres (220 miles) long. Instead, from the Schleswig-Holstein border in the west to Poland on the island of Usedom, the coastline is longer than 1,700 kilometres (1,050 miles) and therefore more than enough to allow us diverse opportunities to share in the sometimes placid, sometimes stormy marriage of water and land.

The Western Pomeranian coast is far more differentiated than that of Mecklenburg – more often than not quite torn up. Large offshore islands and peninsulas not only heighten the attractiveness of this landscape; they are also

the parents of the many inlet lagoons – called "Bodden" – that are typical of this region. The Bodden are largely separated from the Baltic Sea, are far less salty and many seem more like inland lakes than parts of the great sea. Protected from the winds by the surrounding land, and due to their shallowness, waterways such as the Jasmunder and Saaler Bodden or the Achterwasser are especially popular among water sports enthusiasts.

The typical characteristics of Mecklenburg's coast are the large bays. The sea ate its way very deeply into the land by Wismar. The coastline then evens out again between Rerik and Fischland. Fischland is a former island, which joined its Western Pomeranian sisters Darss and Zingst to form a peninsula that cannot seem to stop growing. The sea is constantly adding more earth, which it, naturally, digs up from other parts of the coastline for its maritime sandpit game. The sea giveth and the sea taketh away.

Page 22/23:
The sky above Sellin, with the Baltic and pier in the background and the beach in front. The latter is almost three kilometres (nearly two miles) long and ends at the foot of the steep cliffs upon which the little town is perched.

Pages 24/25:
A view over the harbour of Waren, the main city of the Mecklenburg Lakeland. The Marienkirche dating from the 14th century is in the background. Gutted by fire in the Thirty Years' War, it was not rebuilt until the end of the 18th century. The tower is 54 metres (177 feet) tall.

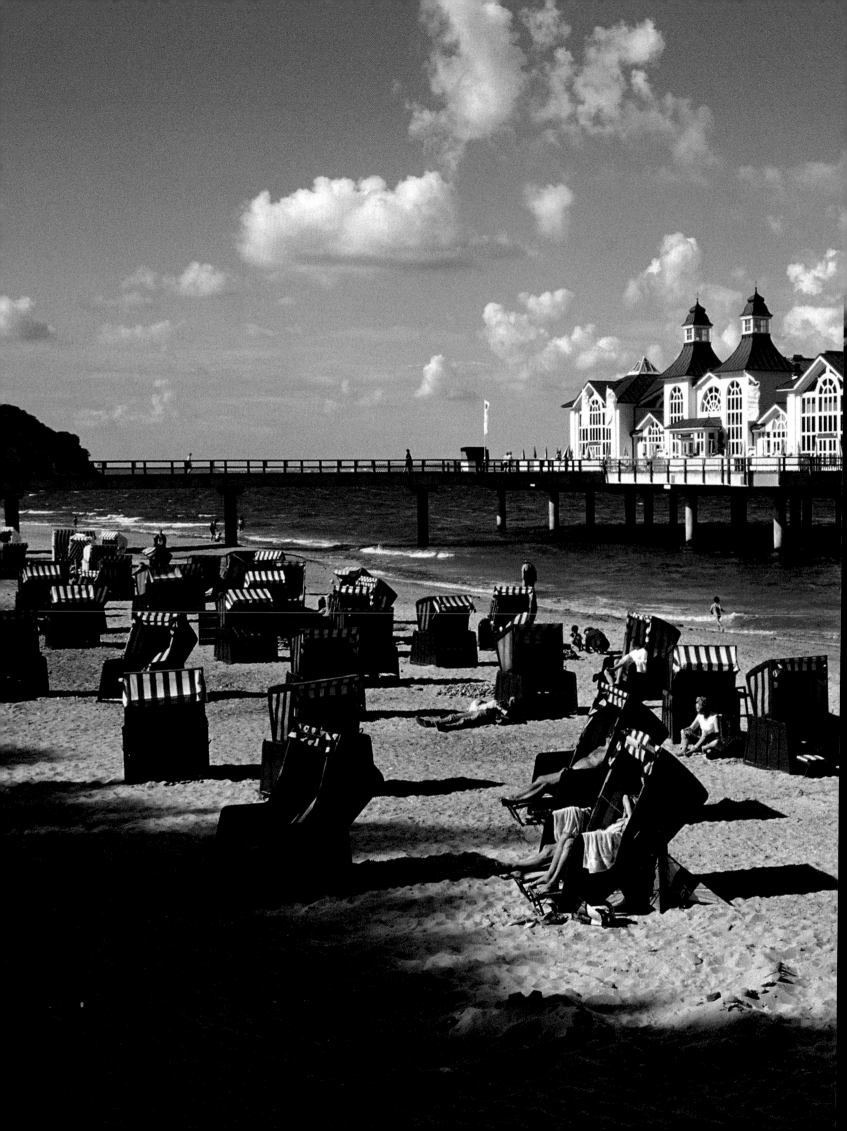

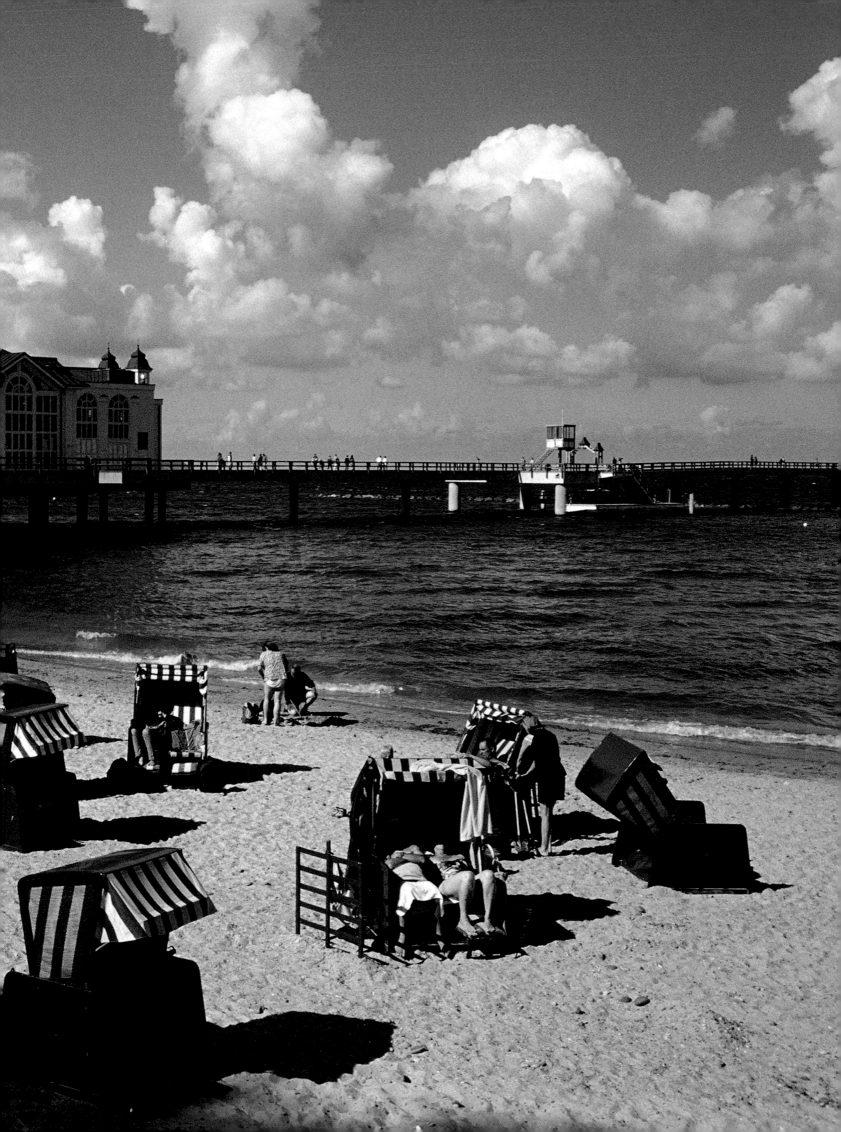

Land in the sea – the Baltic islands

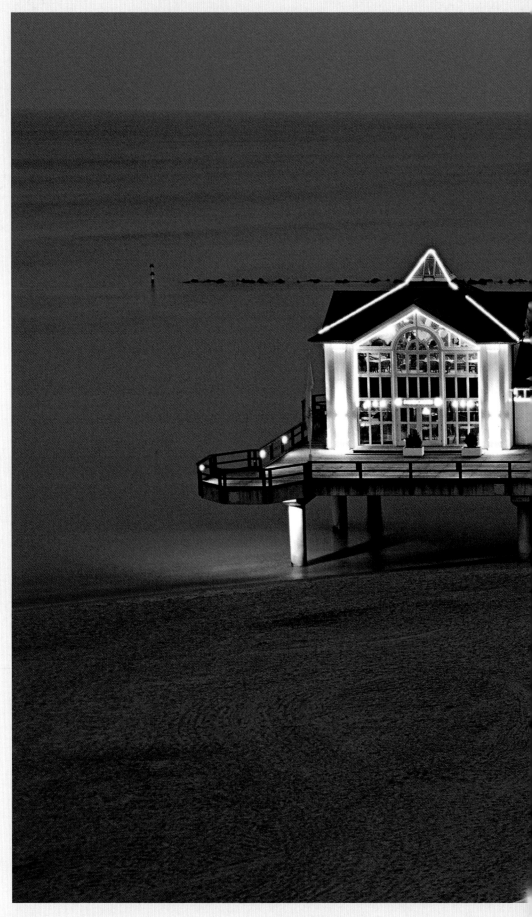

Sellin's development from a tiny fishing village, with only 30 houses at the end of the 19th century, to a seaside resort was closely linked with "Rasender (rushing) Roland". The narrow-gauge railway, still pulled by a steam loco-motive, helped transform a number of towns in the southeast of Rügen to tourist destinations. The town's main attraction is the pier, rebuilt after being destroyed by ice floes in 1941.

All of the German Baltic holiday islands, except Poel in Mecklenburg, belong to Western Pomerania. With over 900 square kilometres (350 square miles), Rügen is almost twice as large as all the others put together. However, it was not always the case. A look at the map reveals countless peninsulas reaching into the sea like octopus arms and a number of lagoons, some of which have become inland lakes. It is obvious that the sea has interlocked a number of islands to form Rügen. The island unites all types of Mecklenburg-Western Pomeranian landscapes with the addition of one magnificent unique formation – the chalk cliffs.

Rügen's famous western neighbour is called Hiddensee. The beauty with the hourglass figure was courted above all by writers, artists and other prominent figures. From Dornbusch in the north, the highest point at almost 70 metres (230 feet), the entire isle lies at one's feet. Your glance sweeps over Kloster and Vitte to the beach at Neuendorf, where the stormy Baltic Sea washed up a diadem in 1872 – the legendary Hiddensee gold ornaments.

Usedom is an island shared by Germany and Poland near the mouth of the Oder River with a size of 445 square kilometres (172 square miles). Sheer endless sandy beaches are its claim to fame, so it is not surprising that it was discovered as the ideal bathing spot in the early 19th century and is still popular today.

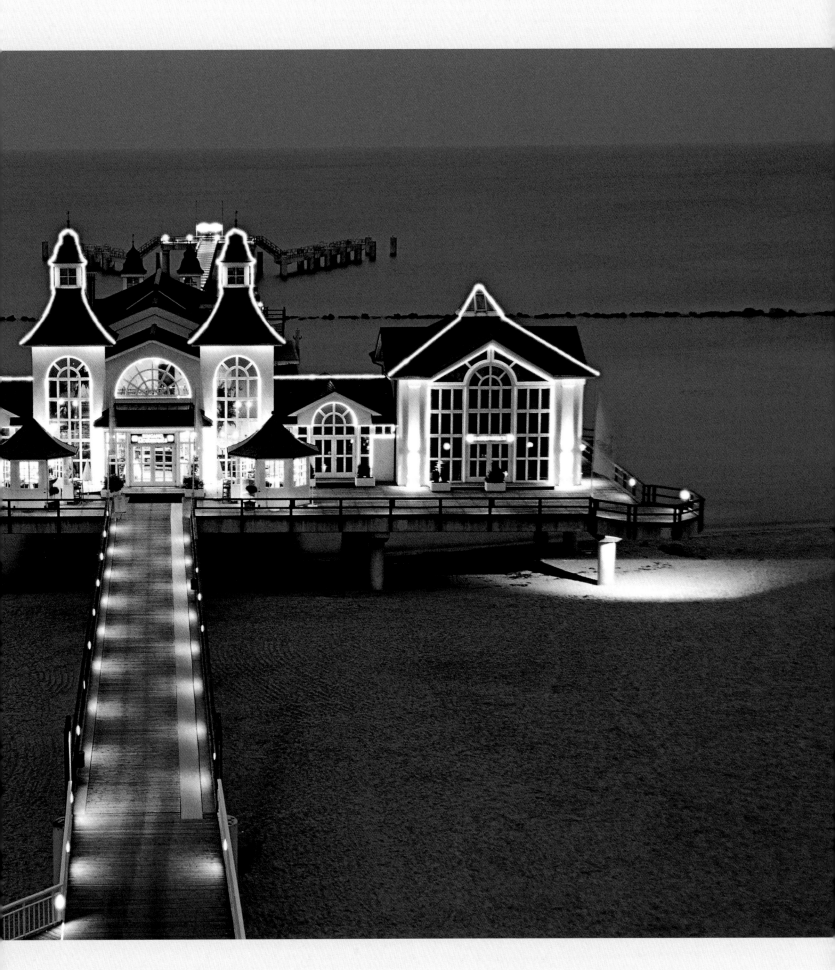

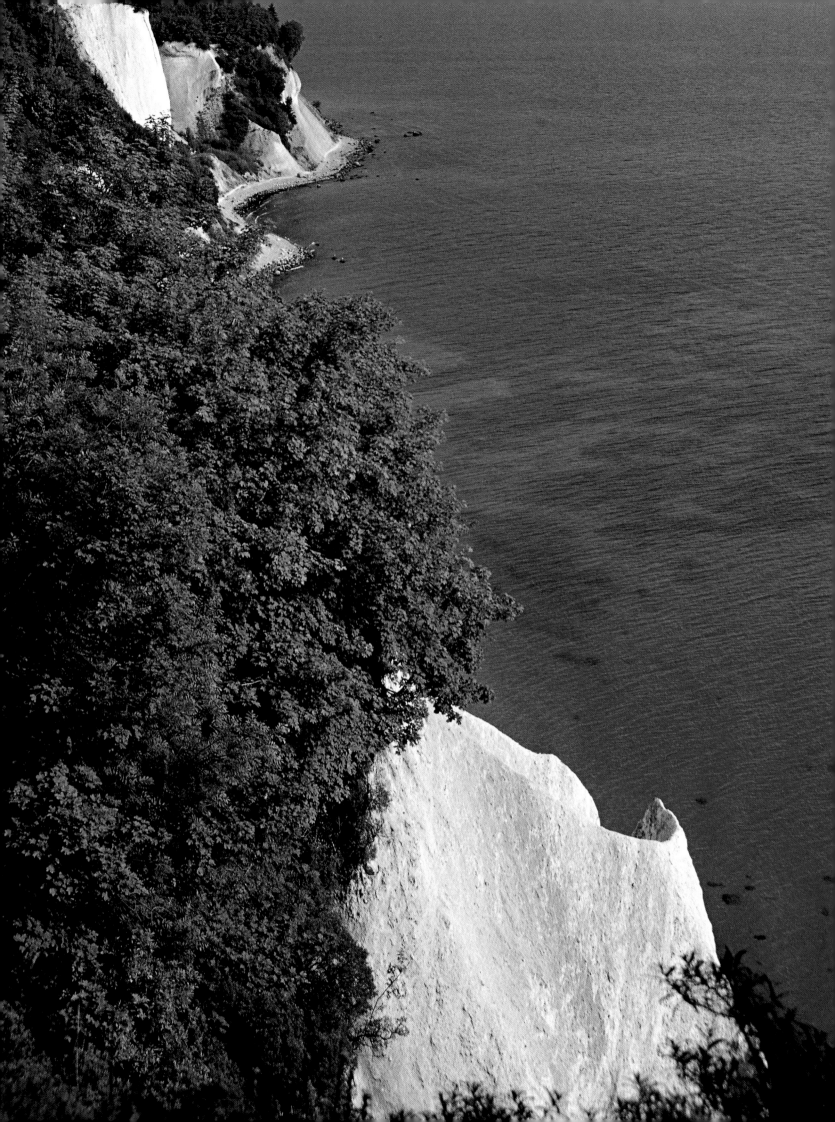

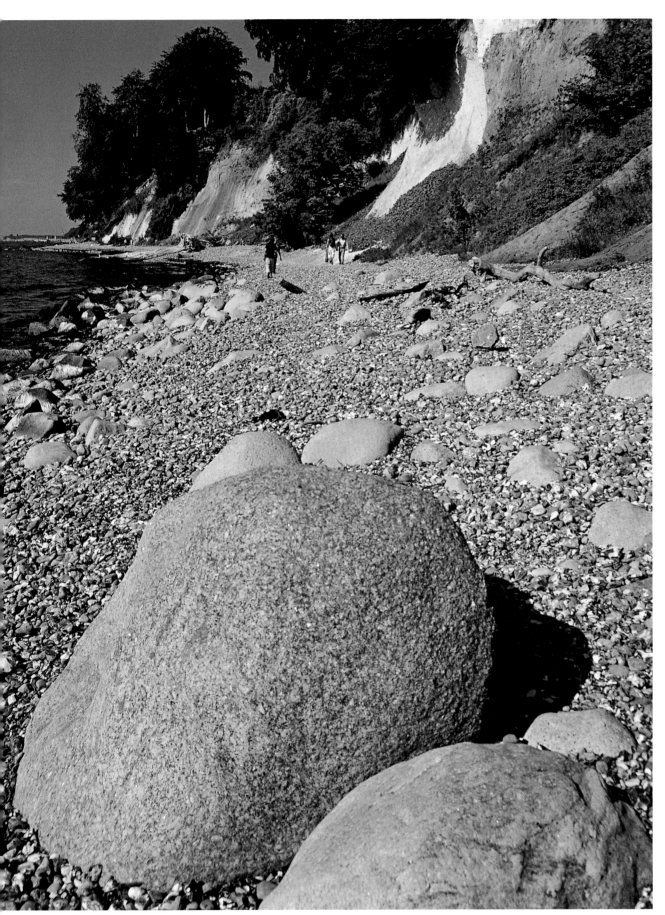

Left page:
Chalk cliffs in Jasmund National Park on Rügen. The national park has existed since 1990 and covers an area of roughly 3,000 hectares (12 square miles) from Sassnitz in the south to Lohme in the north, and is dominated by natural, untouched beech forests.

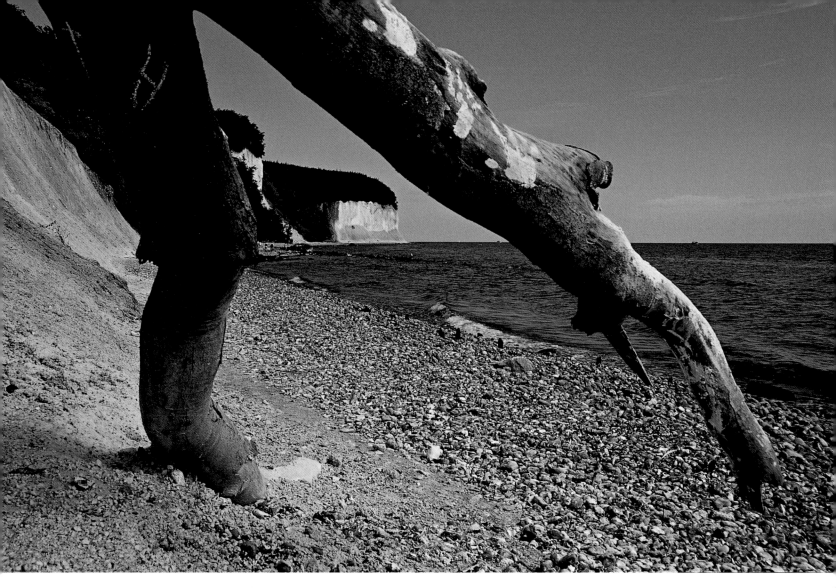

Above:
The sea put Rügen together from a number of islands and in the same way, it is gradually breaking it apart. After it has, literally, pulled the soil out from under the roots of the trees on the coast, it's simply a matter of time before they tumble down the cliffs.

Right:
The sea uses beech wood as well as the wood of ash, maple and elm for its natural sculptures exhibited along the coast of Jasmund National Park. These bizarre objects continue to be shaped until they one day rot away entirely.

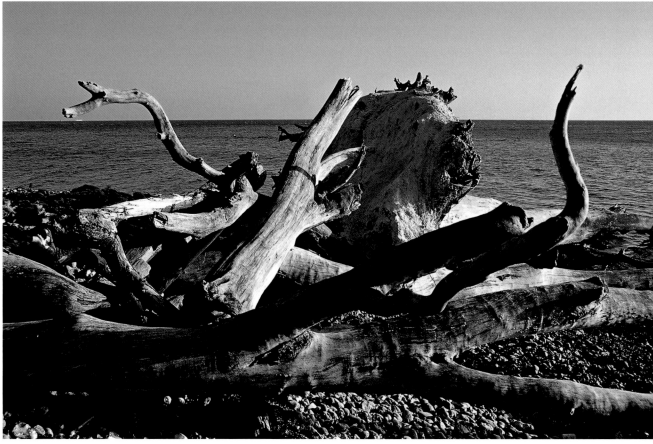

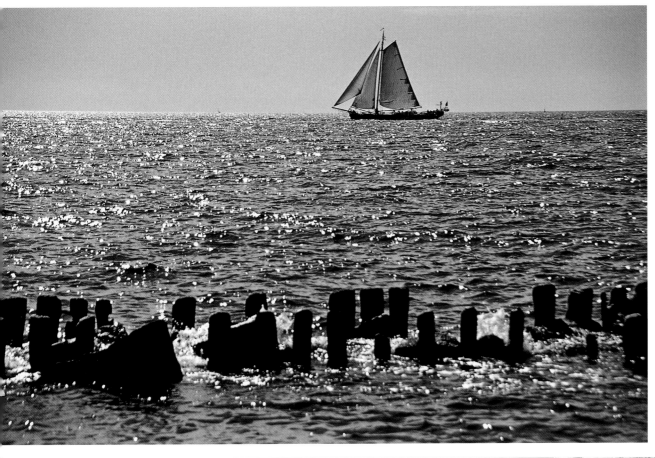

Left:
To slow the sea from stealing away the land, attempts are made to stabilize the shore with groynes. Yet, even these cannot withstand the waves forever. The Baltic Sea is not always as serene as in this picture.

Below:
The chalk deposits on the Rügen peninsulas Wittow and Jasmund are literally prehistoric at 80 million years old. Not only can one admire their fantastical eroded shapes, but also the interesting geological structure, which includes writing chalk and fossil-laden flint layers over a stretch of ten kilometres (over 6 miles) of coast.

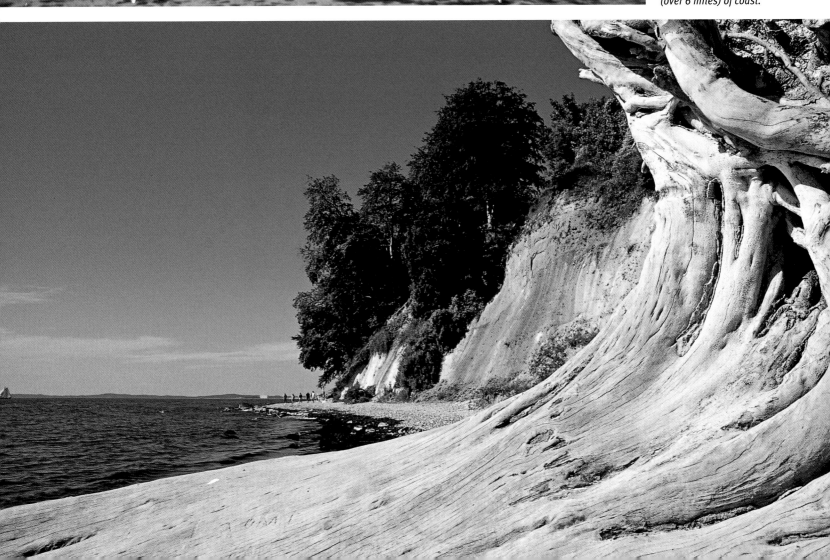

Left page:
The town forming the gateway to the island of Rügen is called Altefähr (old ferry). There was a regular ferry service between Stralsund and this town as early as the 13th century, replaced in 1856 by steamers. In 1936, construction was completed on the 2 ½-kilometre (1 ½-mile) long Rügendamm causeway with the large sound bridge and the Ziegelgraben drawbridge.

In Sassnitz harbour. The little town is situated on a terrace between the Prorer Wiek and the 130-metre (427-foot) high Krampaser Bergen and in GDR times, it was one of the country's most important fishing and commercial towns. This is no longer the case and the population has dwindled by one fourth to about 12,000.

Although fishing only plays a minor role in Sassnitz today, the harbour is a pretty lively place, at least during the summer holidays. Not only fishing boats, but also the popular excursion boats leave from here for the chalk cliffs of Stubnitz.

Page 34/35:
Rügen. On the Wittow Peninsula is the village of Vitt where man and nature coexist so peacefully that UNESCO has duly awarded it one of its cherished accolades. Even if this has served to increase the influx of visitors, thankfully desires to increase the tourist potential of this idyllic spot with "modern" edifices have been thwarted.

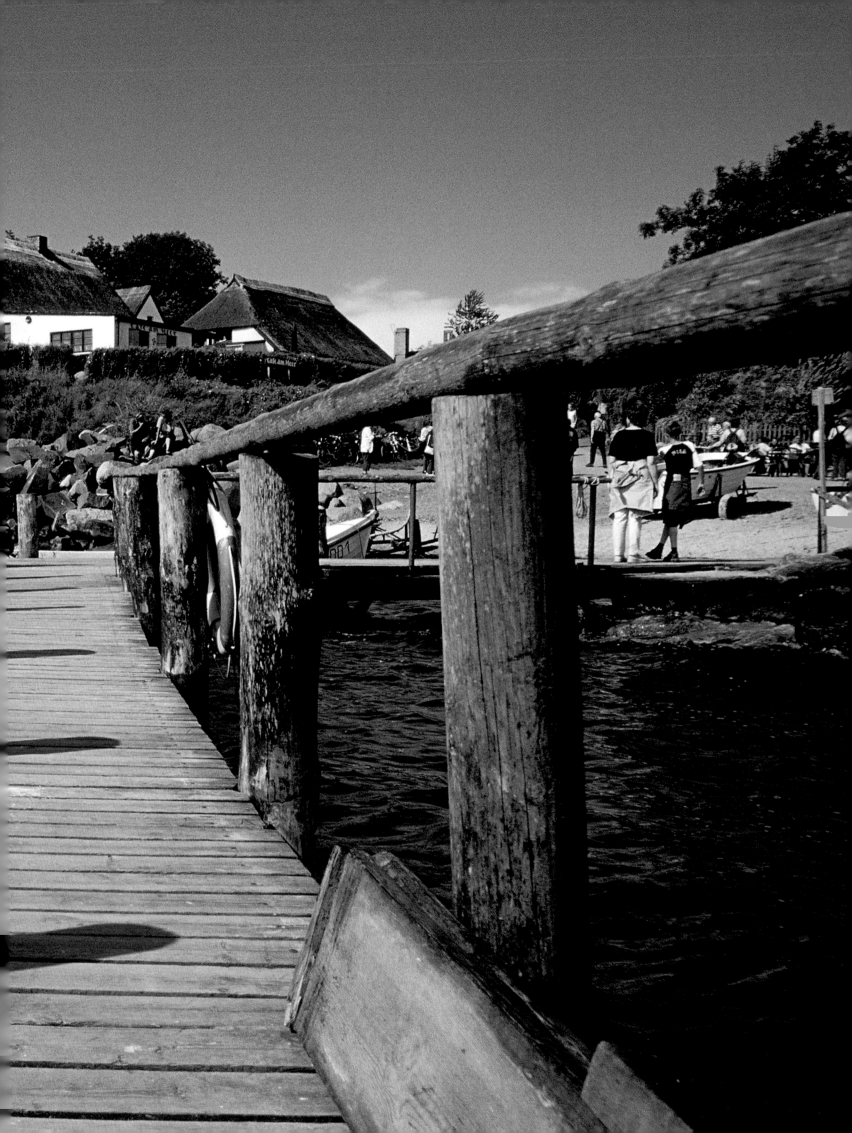

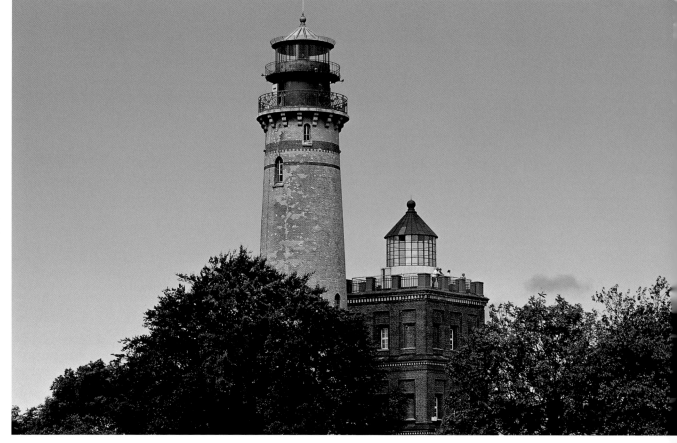

Wittow peninsula and Cape Arkona reach into the Baltic Sea on the northernmost tip of Rügen. The almost 50-metre (164-foot) high chalk cliffs are crowned by two imposing lighthouses in addition to the former navy bearing tower. The square construction erected in 1826/27 was based on plans by Karl Friedrich Schinkel. Another lighthouse was built in 1902, which is higher than the older one by more than 15 metres (50 feet).

View toward Cape Arkona. Its outer edge is surrounded on the landward side by an approximately 250-metre (820-foot) long and on average ten-metre (33-foot) high wall of earth. It once protected the legendary Jaromarsburg, the greatest shrine of the Slavic tribe of the Ranen, which was destroyed by the Danes in 1168.

Right page:
More about the history of this once so imposing temple fortress and the god Swantewit honoured there can be learned at the Marinepeilturm (navy bearing tower), which is not only a museum, but also – like the lighthouses – an ideal vantage point with a sweeping view.

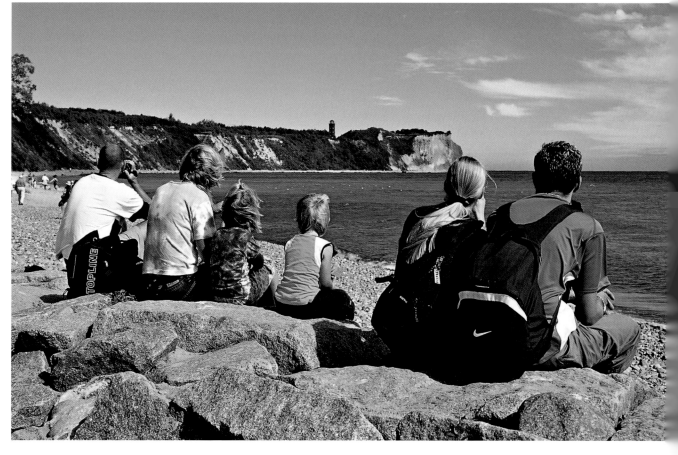

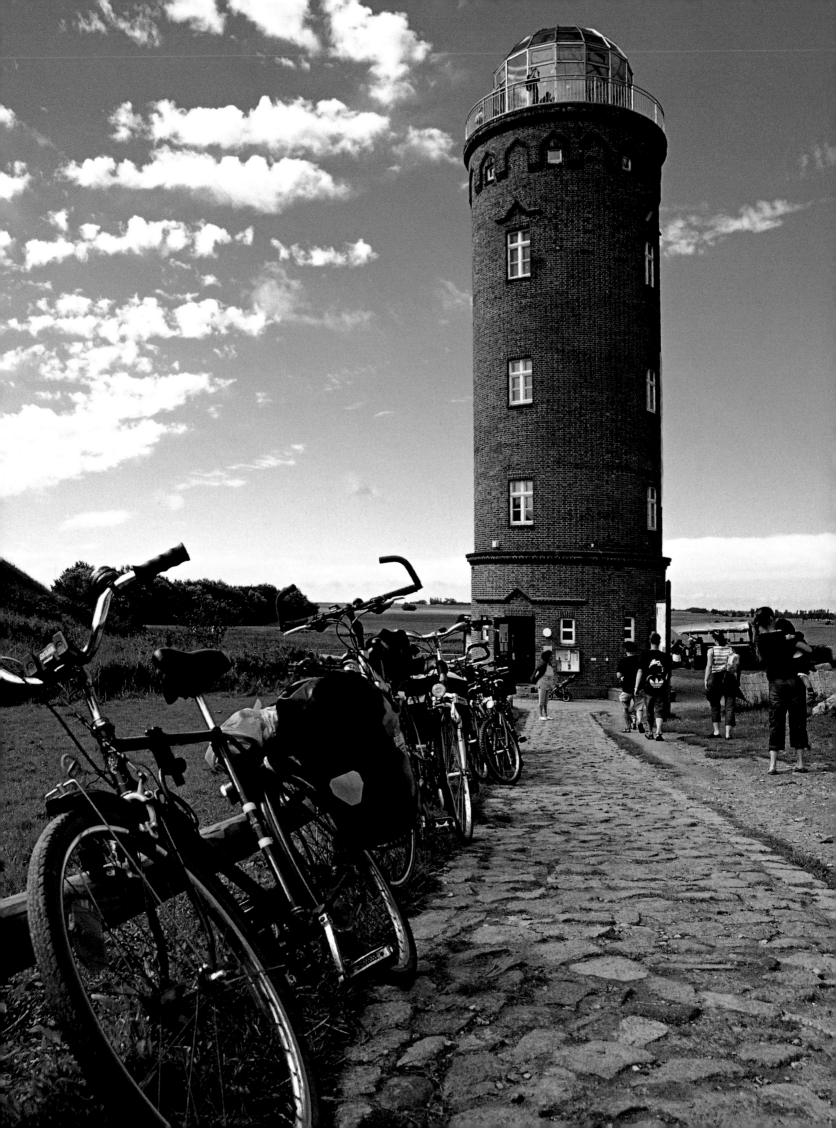

STÖRTEBEKER –
ROBIN HOOD OF THE BALTIC

On certain days in the summer, throngs of people crowd into the little harbour of the otherwise tranquil town of Ralswiek on the Grosse Jasmunder Bodden. There would have been no more on their feet in the 9th and 10th centuries, when the Slavic tribe of the Ranen operated their largest sea trading place there. Today, though, the people don't come for the sake of blatant buying, selling or bartering of wares, but for the sake of a man named Klaus Störtebeker. Although he has been dead for more than 600 years, interest in his life and deeds remains alive. What is known of his past is mainly the stuff of legend, much to the dismay of historians but to the joy of the initiators of the Störtebeker Festival, as it means they can put upon the large (natural) stage whatever they please or – should we say – whatever pleases the public. In front of the magnificent backdrop of the Bodden we experience love and betrayal, plundering and division, battles and murder – not merely on land, but on the water, where the ships blast their cannons at one another until ablaze – or so it seems. Putting our hero in the proper light requires the hard work of fireworks technicians and stuntmen.

Much about the real Störtebeker remains in darkness; we do not even know when and where he was born. Many towns claim him for their own, but tiny Ruschvitz on the peninsula of Wittow in the northeast of Rügen seems the most probable. The saga tells us that it was here that he entered a dispute with his master and then fled by ship to Arkona, where the infamous pirate Michael Gödecke lay at anchor. Störtebeker was able to impress the pirate so with his strength and ability to hold his drink – they say he could bend a horseshoe straight with his bare hands and drink a huge tankard of beer in one swig – that Gödecke let him join his crew. The latter feat may also be the source of his name: "Stürz den Becher" (tip the beaker) = Störtebeker. The year of this fateful meeting between Gödecke and Störtebeker is cited as 1393 or 1394. This means, however, that our hero could not have been involved in Gödecke's most spectacular act. During the battles for the succession of the Nordic crown, the pirate broke through Queen Margaret of Denmark's ring of siege and supplied the hungry people of Stockholm with victuals (= Vitalien) – from which the pirate brotherhood got the name "Vitalienbrüder" that was famed and dreaded near and far.

Robbed "pepper sacks"

Although the Hanseatic League commissioned the Vitalienbrüder for the above coup, this did not stop the pirates from seizing its ships when opportunity arose. In the beginning, it was on behalf of the Pomeranian dukes and later on their own account – which would be their downfall. The "pepper sacks", as wealthy Hanseatic citizens were derisively called, soon began defending themselves. While one Hanseatic foray of 1394 was unsuccessful, four years later an army of the Teutonic Order landed on Gotland where they destroyed the local base of the Vitalienbrüder. Störtebeker, who had risen in rank by then with Gödecke to a leader, was no longer a hunter, but the hunted.

His downfall was only a matter of time. The Hanseatic fleet that set out against the Vitalienbrüder in 1401 did an even better job than its predecessor had: Störtebeker and his men were captured. The fact that this did not happen in a battle on the open sea, but through an act of betrayal while the ships lay at anchor by Hamburg, suits the image of an unbeatable hero, but there is absolutely no proof of this. The year of his execution is certain: in 1401, Störtebeker, Gödecke and the other prisoners were beheaded. Ah, but Störtebeker would not be Störtebeker if he had not demonstrated his unusual powers even on the way from life to death. It is said he ran headless past a number of his mates standing in a row and thus saved them from the death sentence.

Since then, the famous pirate has been commemorated in countless songs, tales and rhymes, making Störtebeker, who not only divided his booty among his crew equally, but also gave generously to the poor, an immortal hero.

DEUTSCHE BUNDESPOST BERLIN JUGENDMARKE

30 +15

»BREMER KOGGE« HANSISCHES GROSS–SCHIFF (1380)
1977

Left:
The broad, pot-bellied cog was the most common form of transport across the seas of the north and both a medium for Hanseatic trade and warring pirate factions. In its latter capacity it could carry up to 100 guns. The illustration shows a commemorative stamp issued by the German post office in 1977

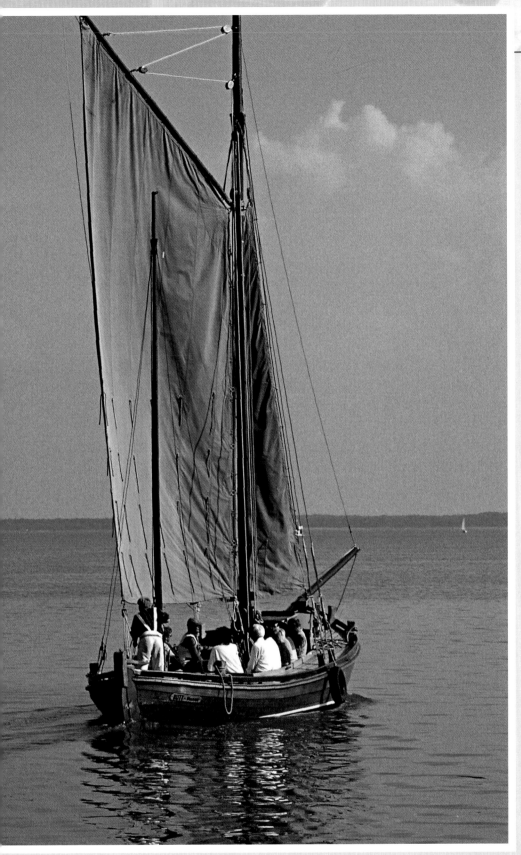

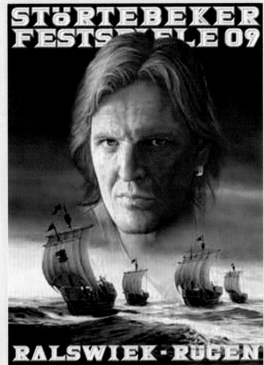

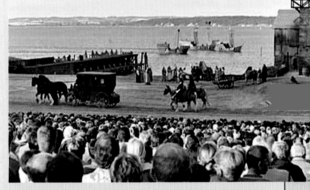

Above:
...sail on the edge of the ...orizon – be it ever so ...mall – was a promise of ...ooty for the Vitalien-...rüder. It is said that they ...ot only divided it up ...mongst themselves and ...e poor, but also hid ...ome of it at various ...laces along the coast, ...uch as Rügen.

Top right:
The Störtebeker Festival in Ralswiek abides by an old rule of the theatre: the hero must not only be a good actor, but good looking as well.

Centre right:
The natural stage of Ralswiek, with the Jasmunder Bodden and the cliffs, is always a magnificent natural backdrop. The pieces of scenery in the foreground change from year to year.

Right:
Stralsund – here, we see Mühlentorstrasse – was once one of the most powerful and important Hanseatic cities. The rich merchants helped fund the spectacular rescue mission when the Vitalienbrüder supplied Stockholm with food while it was under siege.

Below:
Sellin, once the property of
the Putbus princely house,
is one of the largest beach
resort towns on Rügen.
In the late 19th century,
the small-gauge railway

brought droves of visitors.
The centre of Sellin is
Wilhelmstrasse, some of
whose houses date from
the industrial age of the
early 1870s, such as the
"Villa Odin" shown here.

Right:
The hunting seat of Granitz
was built in place of an old
hunting lodge that Prince
Wilhelm Malte of Putbus
deemed too modest. He
had it replaced between

1836 and 1846 by the
present edifice. Today,
Schloss Granitz houses a
museum and a restaurant
in addition to being used
as a concert venue.

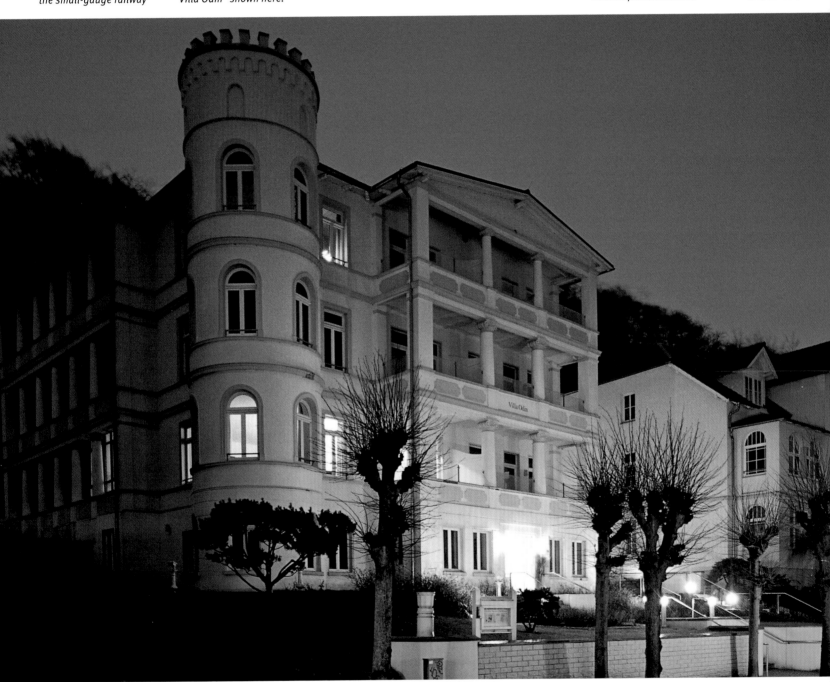

Right:
The prince got the idea to
erect a 38-metre (125-foot)
tower in the inner courtyard

of Schloss Granitz from the
state architect of Prussia,
Karl Friedrich Schinkel. The

tower offers a great view
outside and an interesting
look inside – the cast-iron

spiral staircase is a techni-
cal and artistic masterpiece
of the early Industrial Age.

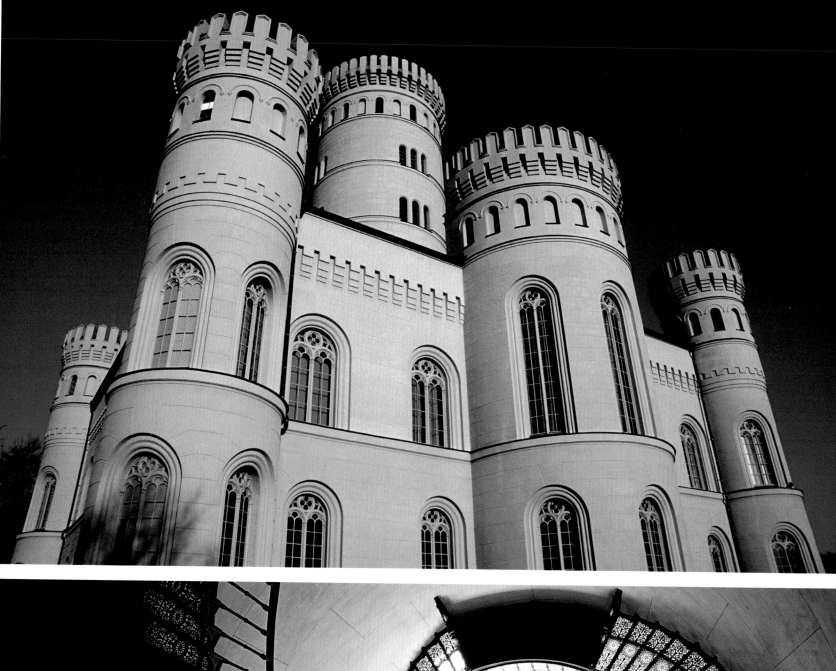

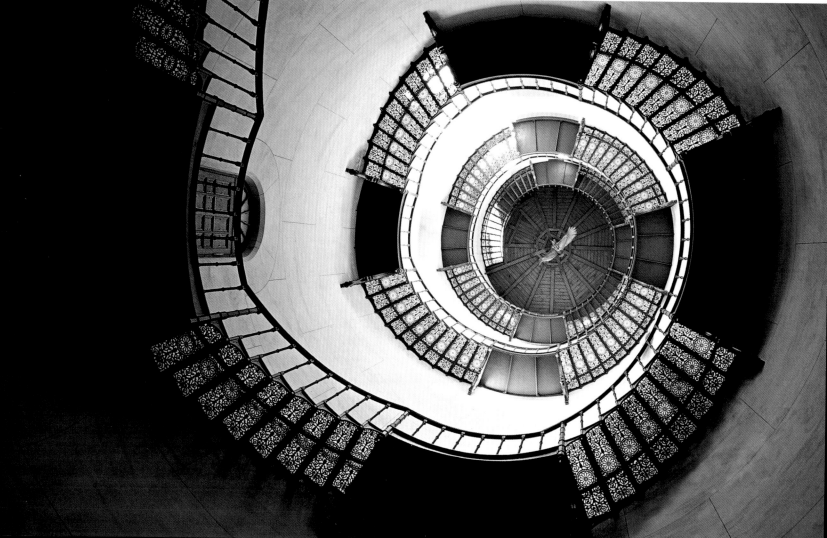

low left:
e of the showpieces
lt by Prince Wilhelm
lte I in Putbus was a
atre. The two-storey
ilding on the market
uare was completed
in 1821 and most of its
original furnishings are
preserved. During the
heyday of the principality,
the theatre even had its
own ensemble.

Below:
Most of the neoclassical
homes that characterize
the townscape of Putbus
were built between 1815
and 1860. The houses here
on the market square are
among the oldest; those on
the famous "Circus" were
constructed after 1836.

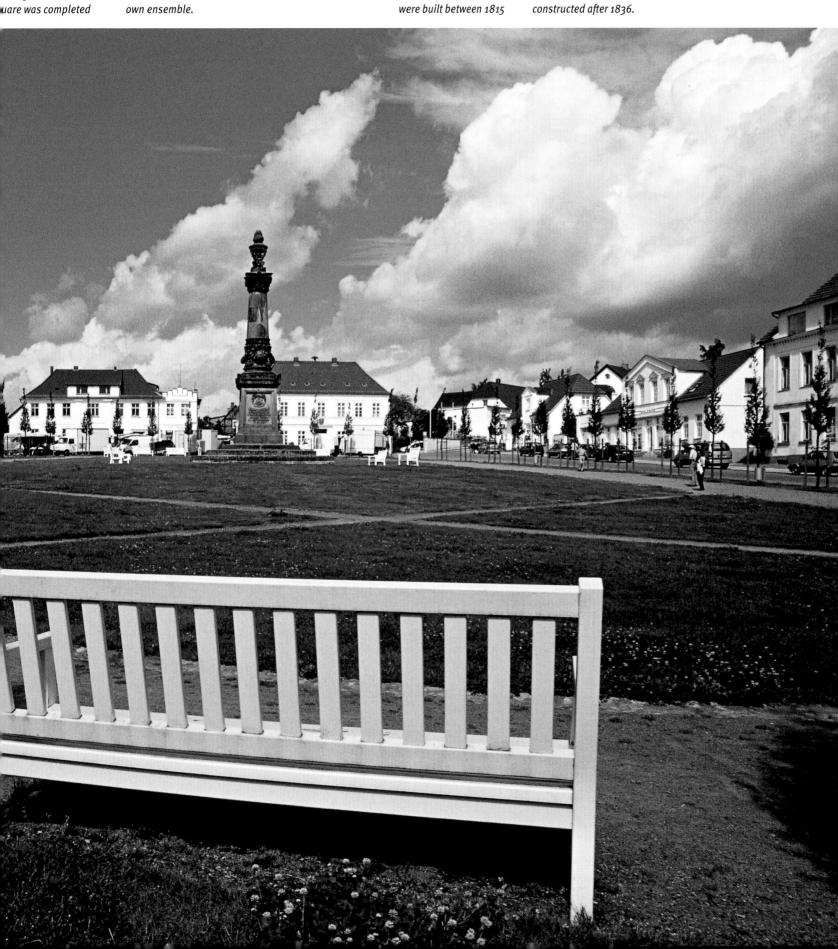

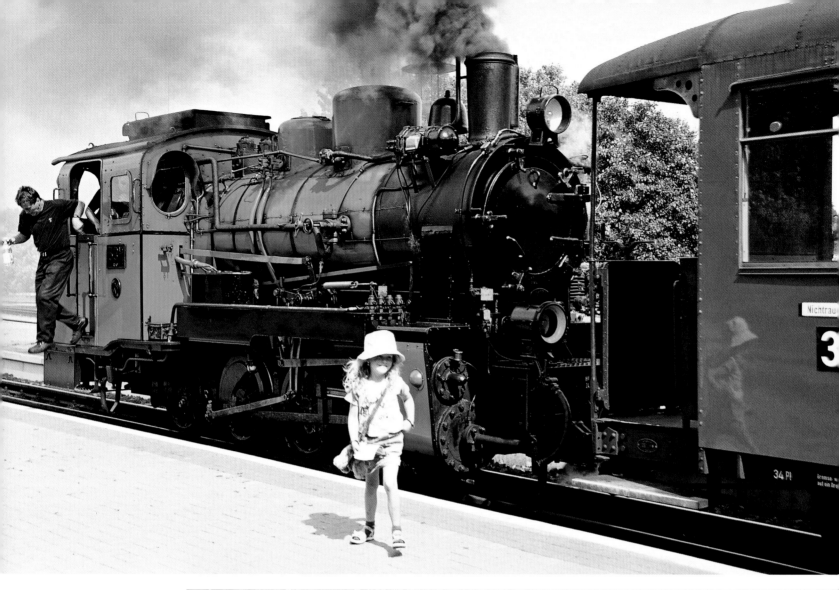

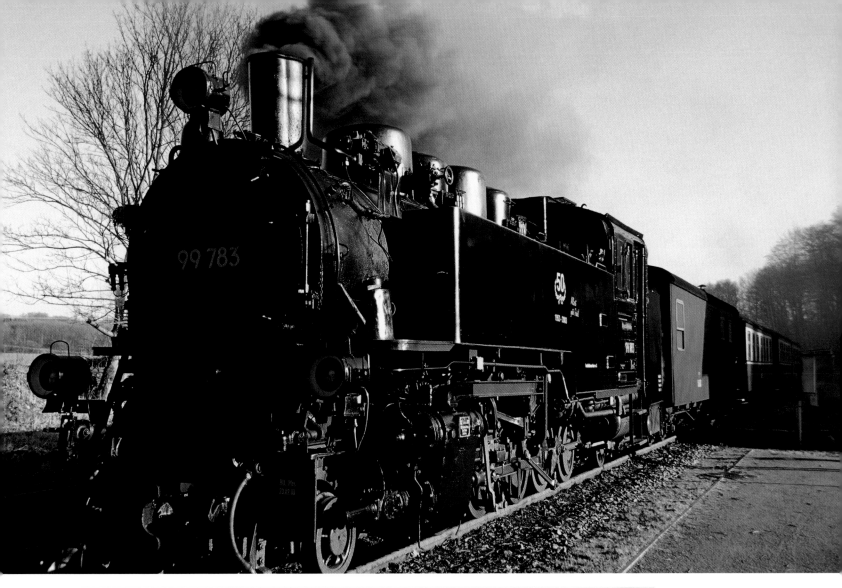

Above:
"Rushing Roland" lets off some steam. Even though the old locomotives have long been replaced by newer and stronger ones, their work is particularly hard during the summer months. Actually, "Roland" never rushes by today's standards. About 30 kilometres (19 miles) per hour are as fast as he goes.

Left:
A tree-lined road near Maltzien. The little town is situated on the Zudar peninsula, the south-western-most point of Rügen, which is usually passed over by the throngs of holidaymakers. This makes the beach at Palmer Ort the right place for anyone seeking solitude.

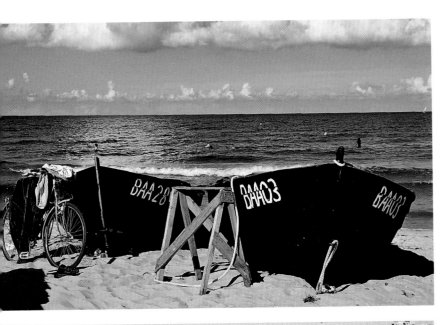

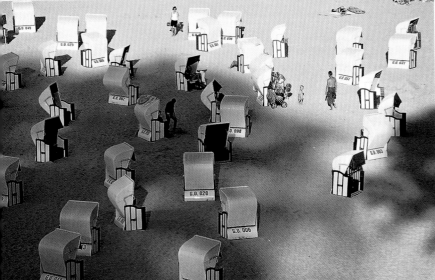

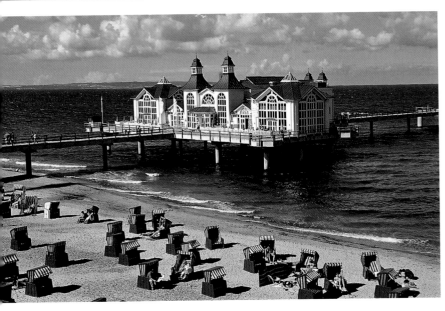

Below left:

Rebuilt after its destruction in the 1940s, the pier at Sellin is not the largest, but it is the most unusual on the entire Mecklenburg-Western Pomeranian coast.

It's hard to believe your eyes when you look down at it from the steep shore wall: the landing stage does not lead straight into the sea, but takes a bend.

Pages 48/49:

Ahlbeck, the largest of the three "Imperial Resorts" on Usedom directly on the Polish border, has the island's only preserved historic pier. The restaurant

pavilion dates from the year 1898; the approximately 250-metre (820-foot) long landing stage destroyed in the winter of 1941/42 was rebuilt in 1993.

en the standard equipent of every "proper" rman beach. They say it as invented in 1882 by a izen of Rostock named lhelm Bartelmann.

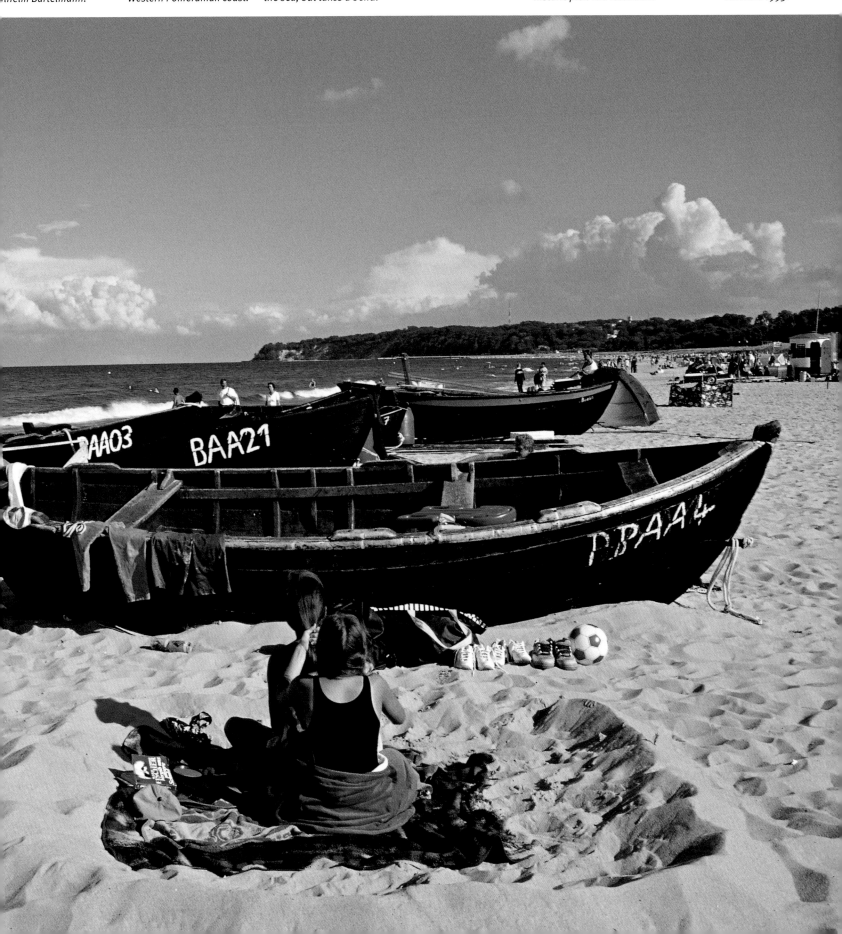

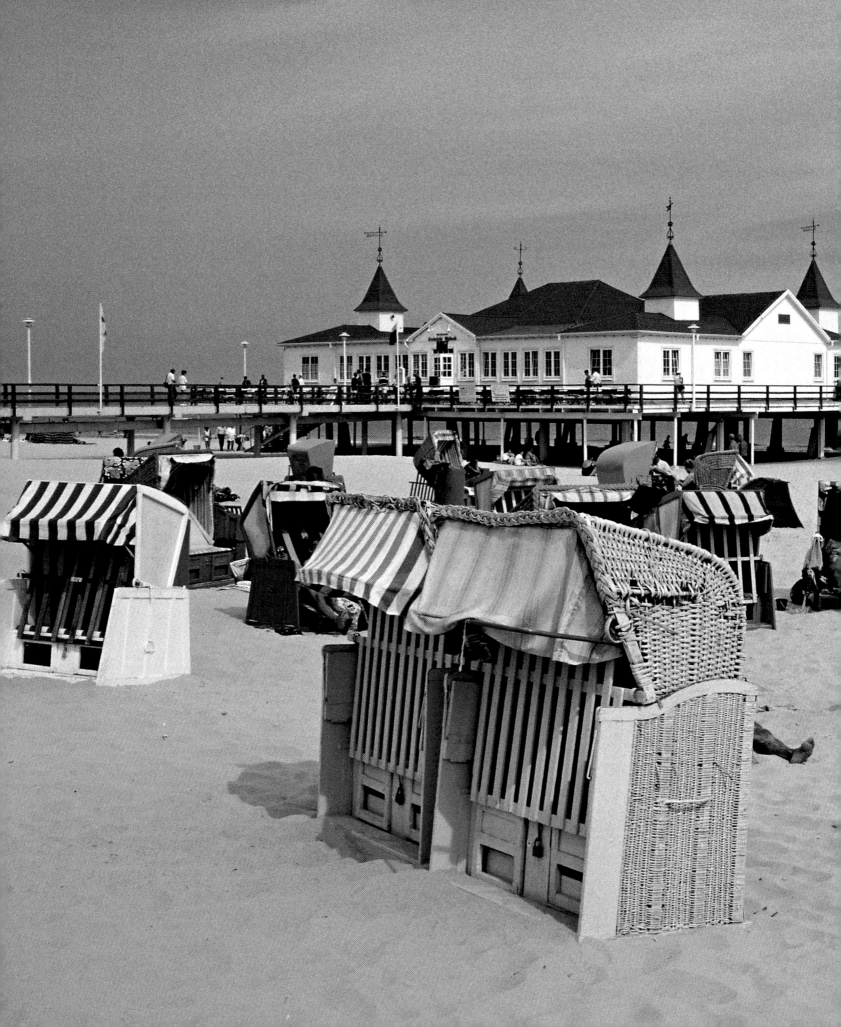

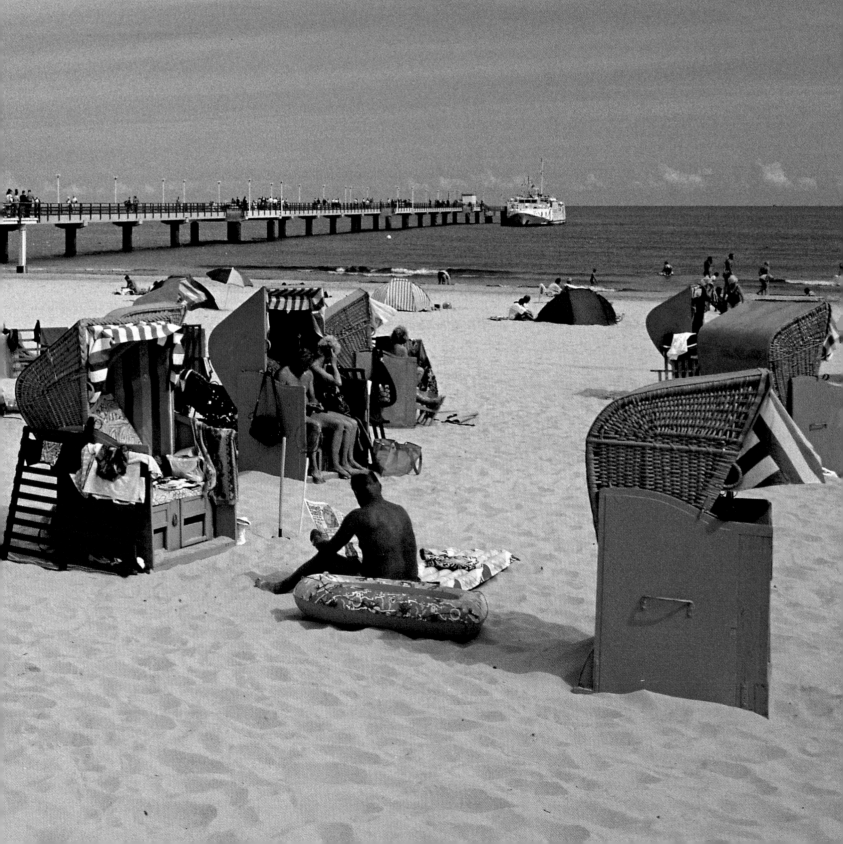

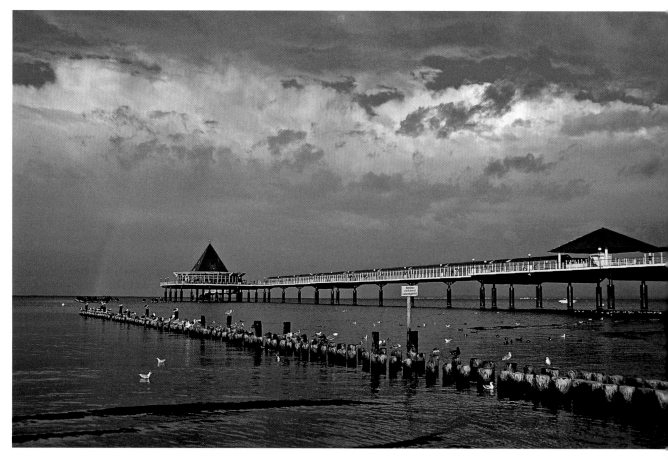

The historic Heringsdorf pier, one of the loveliest on Usedom, burned down a half century ago. A new, larger one was built in 1995, where visitors can eat, drink and even shop to their hearts' content.

In 1820, Prussian King Frederick William III and his son visited the manor owner von Bülow. They were shown the beach and observed the herring catch and barrels. When von Bülow requested that the newly created bathing resort be given a name, the crown prince, later King Frederick William IV, suggested Heringsdorf, meaning "herring village".

Right page:
The beach at Ahlbeck. The largest seaside resort on Usedom was not quite as genteel as Heringsdorf, and even the less well heeled could afford a Baltic Sea holiday. The earliest guests arrived in the year 1852, when estate tenant Stolpe first organized the bathing operations.

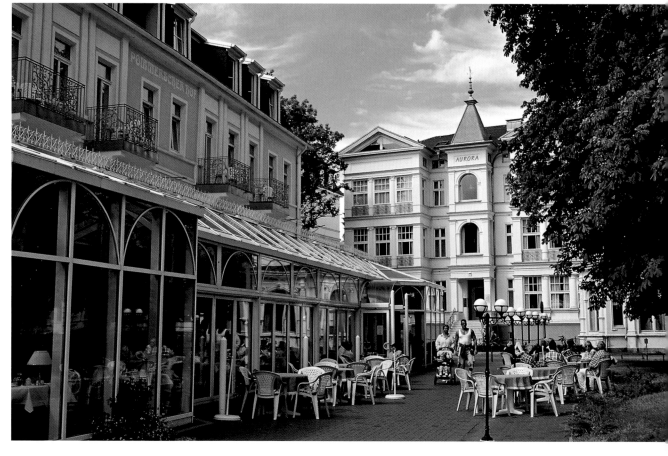

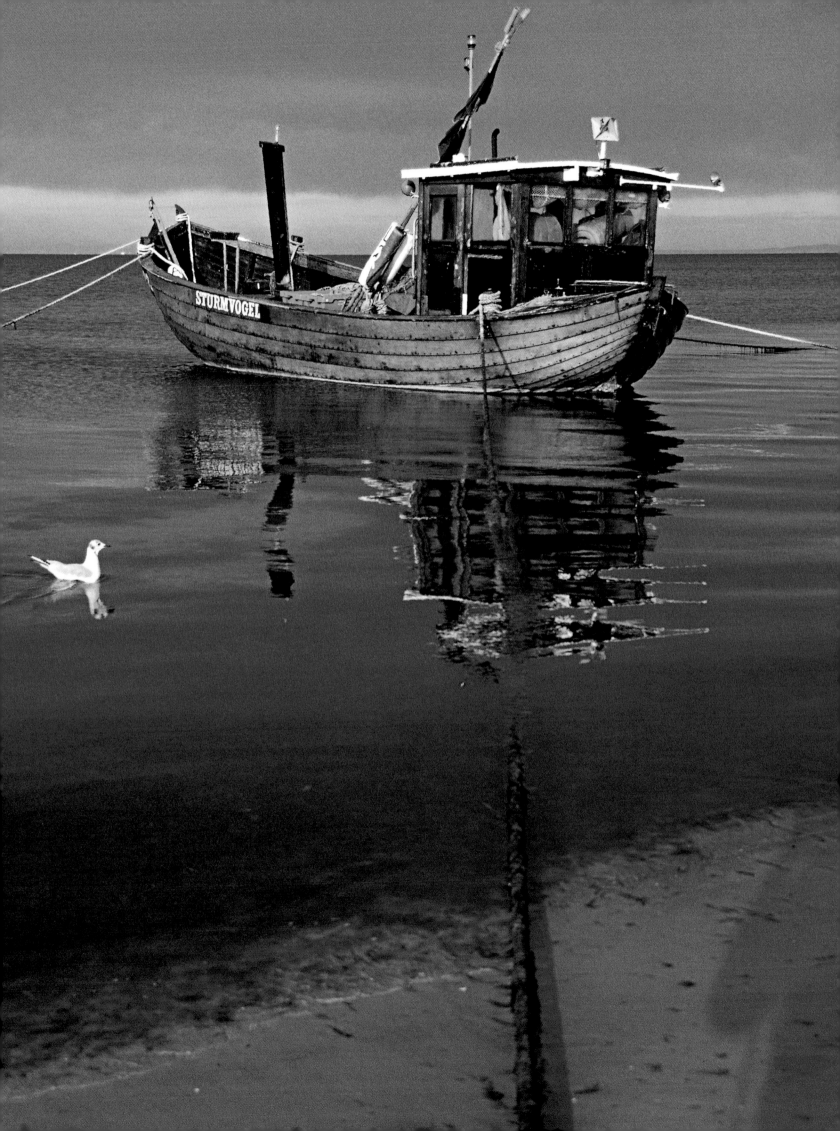

Above:
The biggest tourist hot-spots in Vitte are the former home of the Danish silent movie star Asta Nielsen and the thatched Blaue Scheune or blue barn. The latter has been an artist's studio for the past seven decades and is open to the public.

Right:
This romantic fisherman's cottage with its floral surround is on Hiddensee in Vitte. Many of the houses here have lovely gardens which positively invite admiration and delight.

Above:
The Dornbusch Lighthouse on Hiddensee dates back to 1888 and is thus a good century old. It is 22 metres (72 feet) high.

Left:
In Vitte harbour. Hiddensee's largest village is also the administrative centre of the island. Its name refers to one of the places where in the Middle Ages herring was beached, processed (salted) and then sold.

Endless beaches and picturesque towns – the coast

Pages 56/57:
The Old Market Square in Stralsund is the site of a number of brick Gothic treasures. The "Rathaus" with its 14th century façade is considered the most beautiful town hall in all of northern Germany. Construction of the Nikolaikirche, right next door, was begun in 1270 and completed after approximately 90 years. It is the oldest of the city's three large churches.

Right:
On the beach at Heiligendamm. Germany's first seaside resort goes back to Samuel Gottlieb Vogel, then personal physician to the dukes of Mecklenburg. He was able to persuade Friedrich Franz I of Mecklenburg to test the waters and – in the hope that others would follow suit – to build a bathing hut here three years later.

The entire northern end of Mecklenburg-Western Pomerania flirts with the Baltic Sea. Not only humans profit from this close relationship between land and sea, but the flora and fauna as well – if left to their own means. Therefore, the dunes, beach lakes, reed belt and salty meadows between Darss and western Rügen have been placed under protection. The Western-Pomeranian Bodden Landscape National Park covers roughly 800 square kilometres (300 square miles), four-fifths of which are water. It is the year-round or seasonal home of many birds, including endangered species. The cranes apparently feel most at home: the national park is their largest central European resting spot on their migration route to the south. Over 50,000 of them stop here every year.

Naturally, human visitors are just as welcome on the coast of Mecklenburg-Western Pomerania. There are no obstacles to the pleasures of swimming, sailing and surfing the waters or to the inland diversions of horseback riding, golf, discotheques and casinos – if you don't leave the latter with empty pockets. Warnemünde, situated before the gates of Rostock, forms the ideal link between beach and city life.

The Old Towns of Wismar and Stralsund gained relatively recent UNESCO merit when they were named World Cultural Heritage Sites in 2002. Additionally, the histories and lore of other coastal towns such as Greifswald, Barth or Bad Doberan, as well as the many little idyllic fishing villages, are well worth a visit.

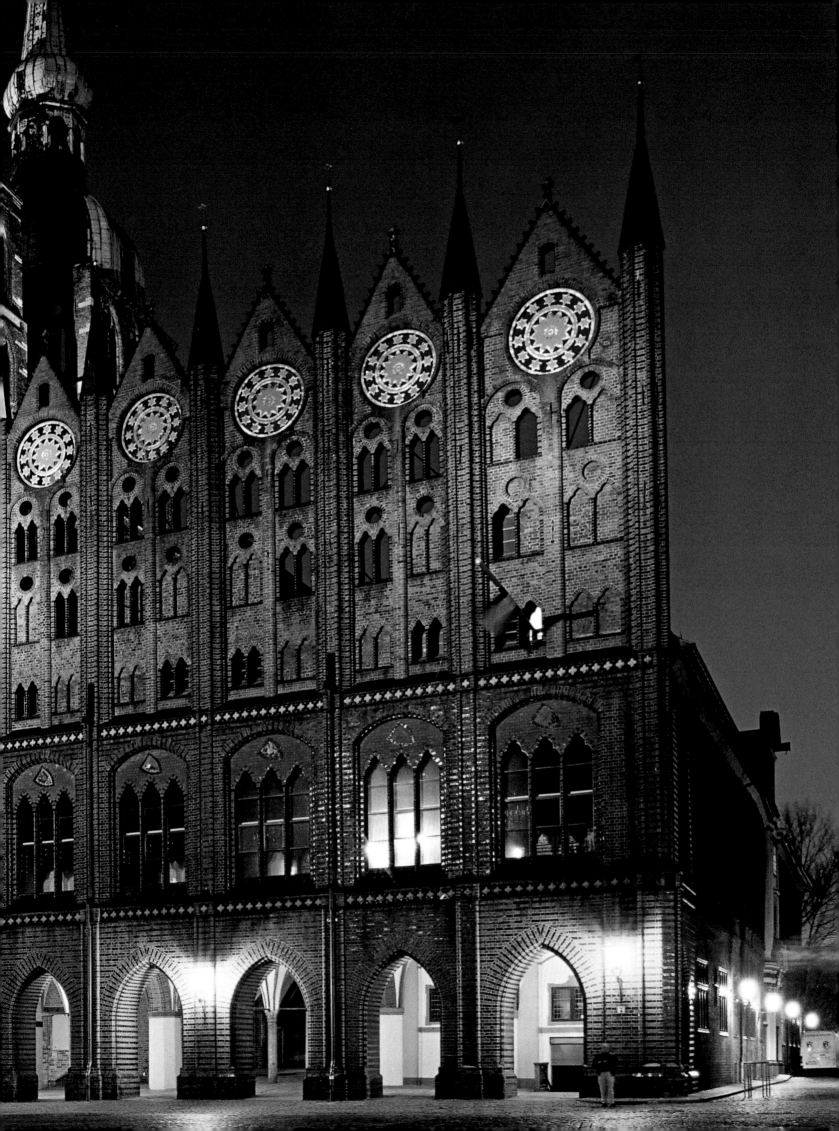

Above:
Like the Old Market Square, the nearby Mühlenstrasse is one of the oldest parts of Stralsund. The many historic townhouses, including the oldest gabled house of the city from the 13th century, proudly show their age in bright new colours.

Right:
Over the centuries, Stralsund "Rathaus" or town hall was given a number of additions and alterations. The staircase in the northern passageway was added during the Renaissance age, while the pillared gallery in the inner courtyard is a child of the Baroque.

Left:
Wulflam House is among the showpieces on Stralsund's Old Market Square. In the second half of the 14th century, the Wulflam dynasty was one of the wealthiest, as well as one of the most ruthless of the Hanseatic League on the Baltic. The building dates from about 1370.

Below:
Like the town hall, many of the smaller townhouses on the Old Market Square of Stralsund lean up against the large Nikolaikirche. For centuries it was common to build the gable side to the street, yet the late Baroque "Commandanten-Hus" is one of the first eave-fronted houses in the city.

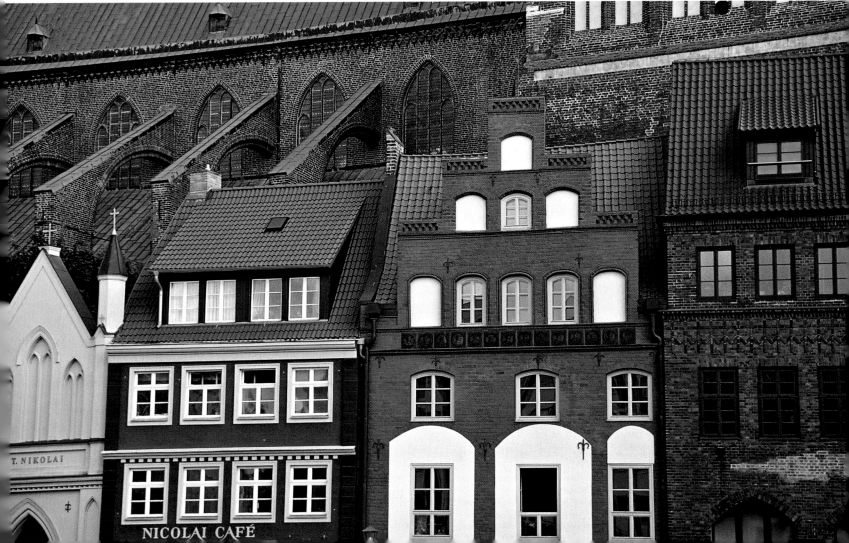

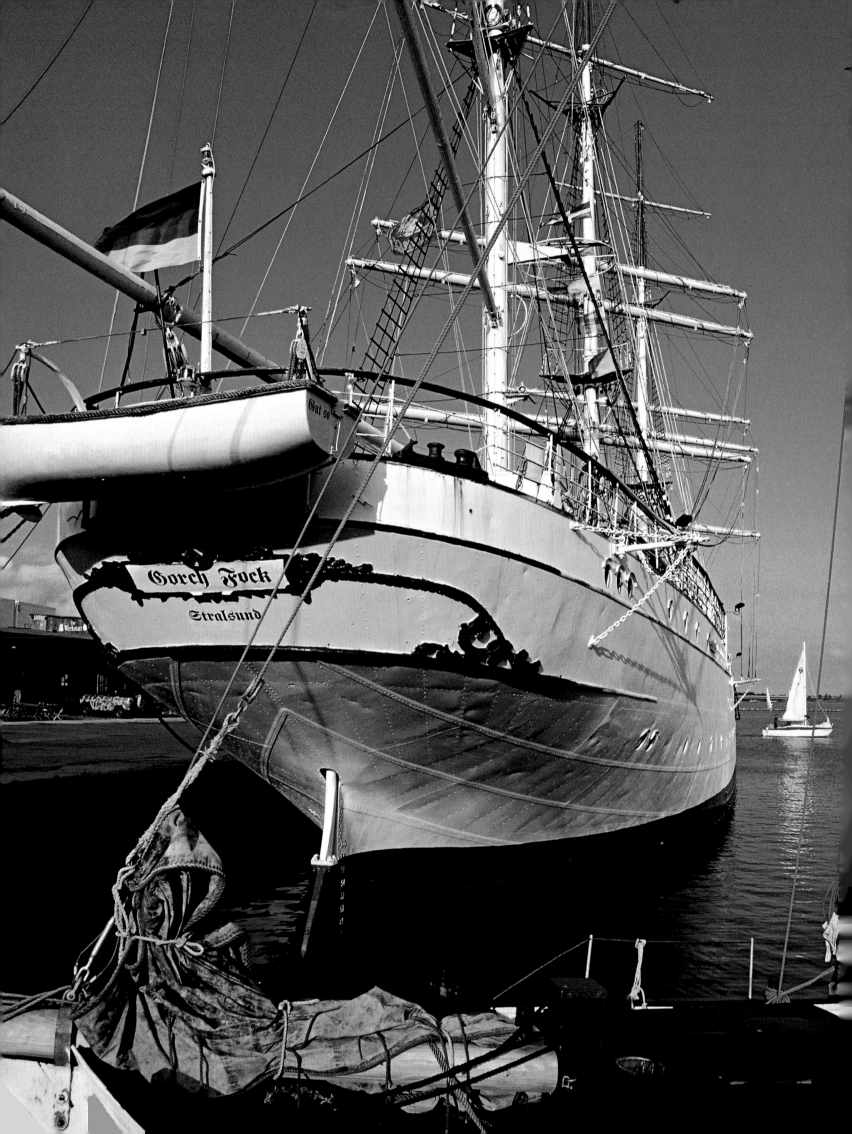

Left page and left:
*The "Gorch Fock I" has
anchored at Stralsund
since 25 September 2003.
First launched in 1933,
at the end of the war the
legendary training sailing
ship was blown up, later
salvaged, rebuilt and
transferred to the Soviet
merchant navy, where
it served as a training
ship under the name
"Tovarishch". After the
collapse of the Soviet
Union, the "Gorch Fock I"
was returned to Stralsund
via Wilhelmshaven. The
ship was named after a
writer (real name Johann
Kinau, born 1880), who
lost his life in the great
sea battle in the Skagerrak
in 1916.*

*The harbour of Stralsund,
which was founded by
German settlers in 1230
and granted the Laws of
Lübeck. Thanks to its
favourable position on the
Strela Sound (it had six
gates to the water, but only
four on land) the city grew
to become one of the most
significant in the Baltic
region. As early as 1303,
the first Stralsund cogs
anchored in an English
port.*

Below:
Since 1886, the wooden
bascule bridge over the
mouth of the Ryck has
linked the eastern Greifs-
wald districts of Wieck,
a former fishing village,
and Eldena, known for its
famous monastery ruin.

Below:
A look across Greifswald
market square at the tower
of St. Nikolai Cathedral,
each storey of which gets
newer the further up one
looks. They say that the
Baroque tip dating from
1653 missed the 100-metre
mark by three centimetres.

Righ
After Greifswald w
granted a city charter
1250, it developed int
blossoming Hansea
city. This photo shows t
market square with han
some gabled houses a
the Marienkirche. T
populace has nicknam
the church "Fat Mary" d
to its stout architectur

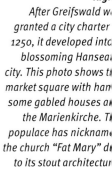

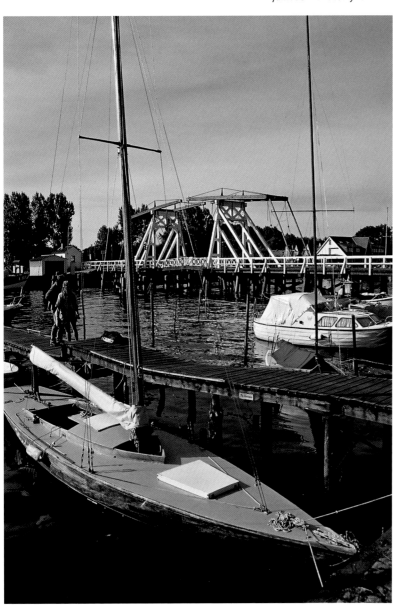

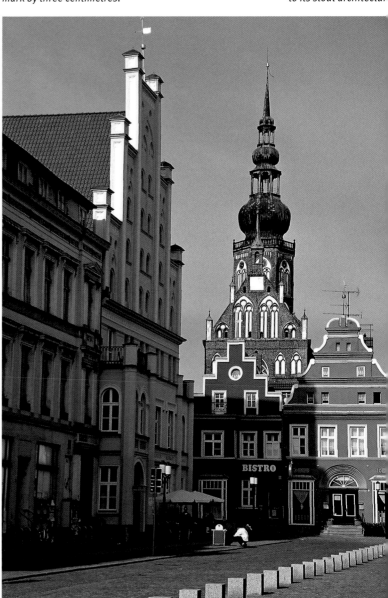

Right:
The market square of
Ueckermünde in the Oder-
haff. The town received the
Laws of Lübeck in 1260. The
Thirty Years' War reduced

the population to eig
men and seven widows, b
under Swedish and – fro
1715 – Prussian rule the c
grew to become an impo
tant centre of shipbuildin

The buildings in the harbour at Prerow also mirror the typical architecture of the coast. Thatched roofs, for instance, are a must! There are plenty of ship and boat trips on offer here, too, and lots of wonderful scenery to explore well away from the fish stalls and discos.

Right page:
Where banks of reed and areas of swamp characterise the Bodden, further out towards the sea the Weststrand or west beach of Darß is one giant sandpit. The walk to its halcyon shores takes you through dark, primeval forest.

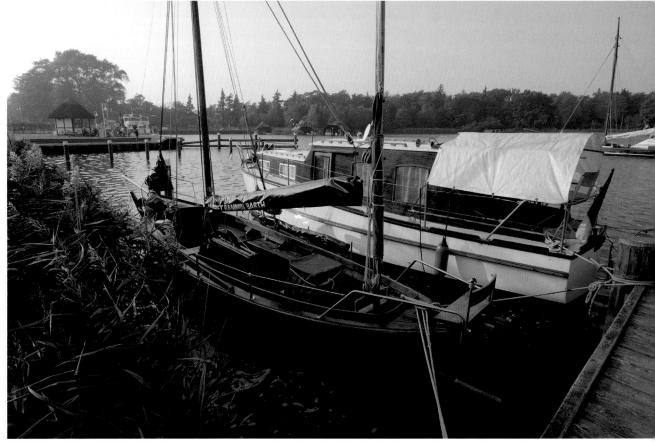

Harbour bay near Prerow. The seaside resort of Prerow is on the Darß, the central section of the Fischland-Darß-Zingst Peninsula. Surrounded on two sides by water, the scenery here is extremely diverse. Despite the vast number of holiday guests the area effuses a great sense of calm and tranquillity.

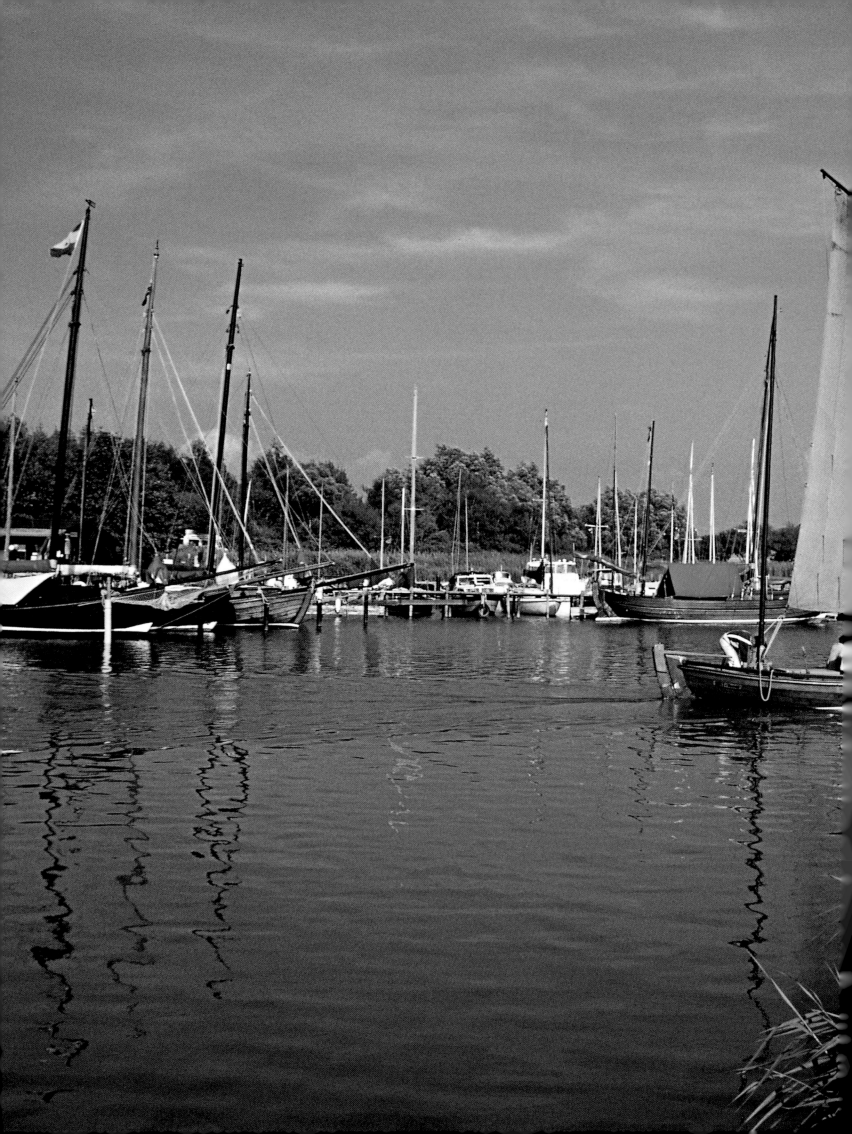

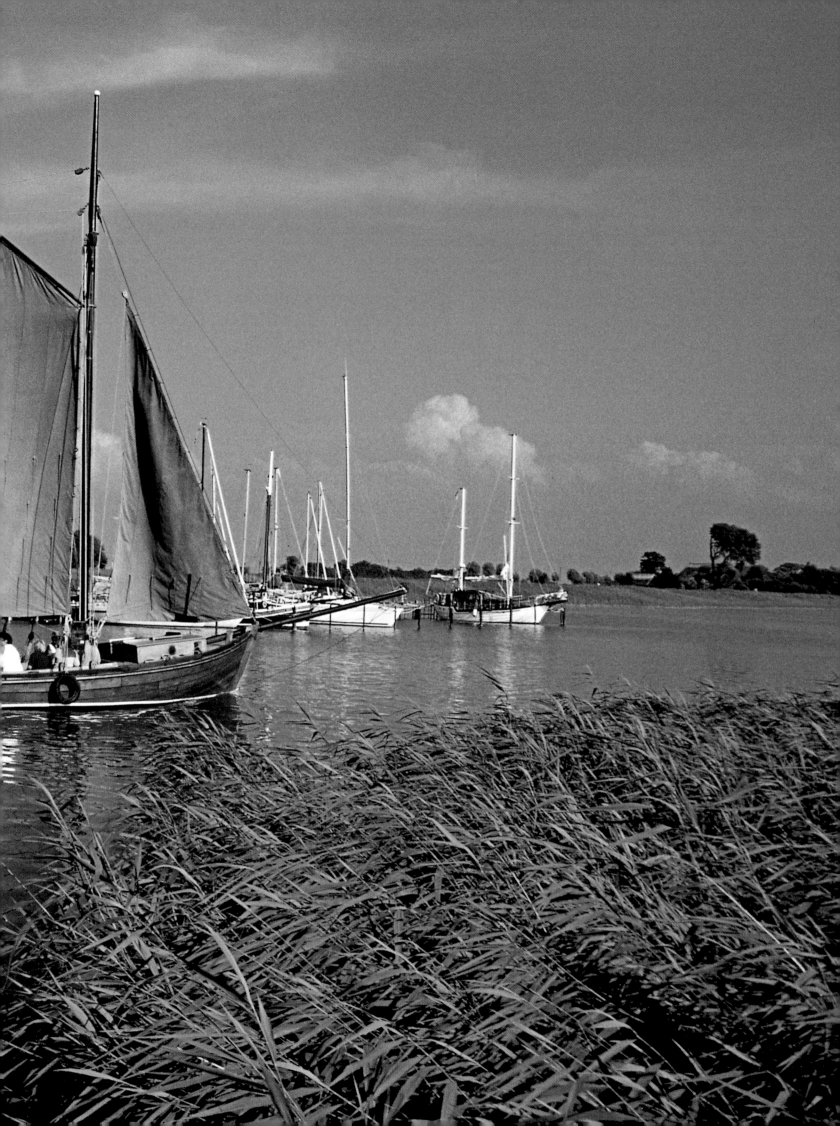

Pages 66/67:
The harbour at Wustrow.
This Baltic Sea resort lies
in the middle of the tiny
island of Fischland between
the Saaler Bodden and
Baltic Sea and has a long
seafaring tradition. The first
German merchant navy
school was founded here.

The beach at Ahrenshoop
is one of the most romantic
spots on the whole Mecklen-
burg-Western Pomeranian
coastline. It has fine, white
sand and picturesque cliffs
called the "Hohe Ufer"
whose appearance are
constantly changed by the
assaults of the sea and
wind. The tiny seafaring
and fishing nest on the
western end of Pomerania
was first "discovered" in
the late 19th century by
northern German painters,
who came here to relax
and work. They were soon
followed by other famous
artists from Germany and
abroad such as Alexey von
Jawlensky, Erich Heckel or
Gerhard Marcks as well as
many other public figures
including Albert Einstein,
Gerhart Hauptmann and
Bert Brecht.

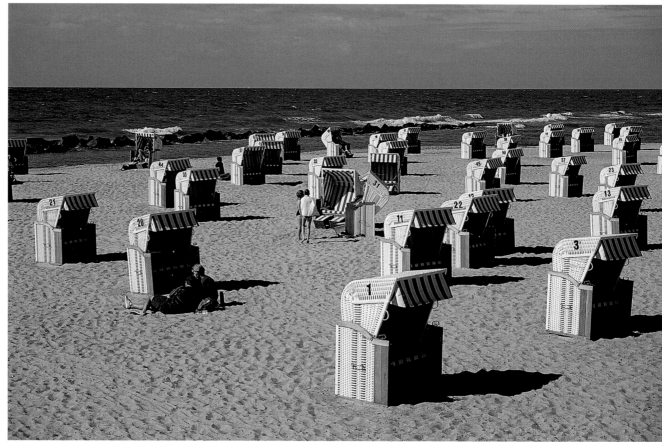

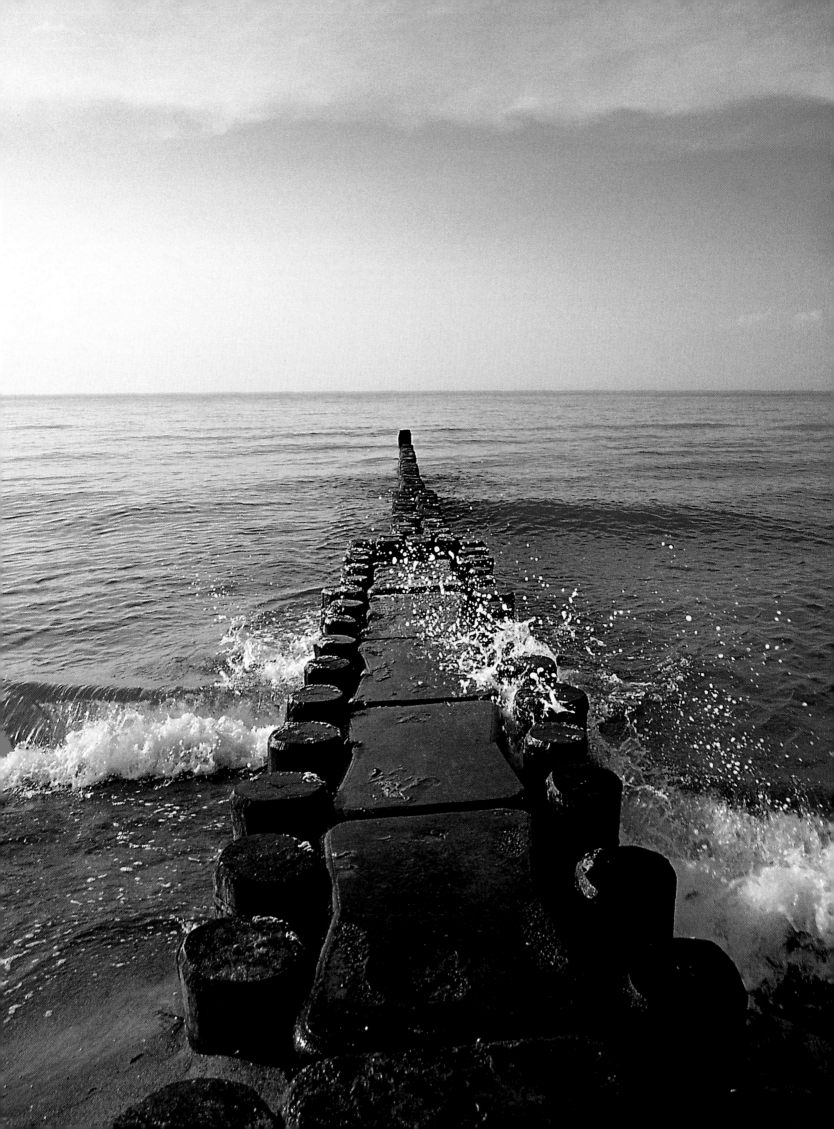

THE BIRTH OF THE BALTIC SEA RESORTS

Covered modestly from head to toe for centuries, it took the Age of Enlightenment in the 18th century before people allowed a bit of sun and a bit of water to touch their skins. The old-yet-new recognition that bathing in the sea could be beneficial against rheumatism, ischemia, skin rashes and sluggish digestion first took hold in England. From there it reached the Baltic Sea, where Germany's first seaside resort was built. This was on the Heiligen Damm near Doberan, where Duke Friedrich Franz I of Mecklenburg had a summer residence. In 1793, the duke's physician, Samuel Gottlieb Vogel, convinced him to take a dip in the water – which he apparently enjoyed so much that three years later he had a bathing house erected. This was gradually followed by a whole row of villas that finally grew to become the famous "White City on the Sea". Over the years, time took its toll, but today, after long and costly restoration and modernization, what MERIAN calls the "loveliest antique on Germany's coast" presents itself for luxurious summer holidays in a nostalgic neoclassical wrapper. The most prestigious historical building is the "Kurhaus" dating from 1816 – a temple of bathing in the truest sense of the word, upon whose gable a Latin inscription ensures those who enter: "Joy greets you here, when you leave the bath in health."

What a time that must have been, when the bathers, lacking other suitable accommodation, moved into the fishermen's huts, who in turn moved with their families and belongings into sheds! Even later, after hotels and pensions began shooting up from the ground, such quarters remained customary for many years. Even the act of swimming itself required a sort of housing in those days. Huts, wooden partitions and other lean-tos were set up to protect the guests' lack of attire from curious eyes. It was a long time before open beaches and free swimming in the sea became everyday occurrences. This explains why Germany's first seaside resort was situated not on a lovely sand beach, but at the Heiligen Damm, a flint stone embankment: back then, no one would have even dreamed of lying down on it.

The rich and famous by the sea

These fears of the water, sun and air had something to do with social rank. The more clothing the people took off, the tighter they clung to their social status; i.e. they began to divide into groups. For example, the nobility preferred Heiligendamm and Putbus on Rügen, while the theatre and film folk favoured Heringsdorf. Romantic Ahrenshoop, with its reed-thatched cottages, gained a special reputation as an artists' village. Yet, the most illustrious – literary figures such as Franz Kafka, Thomas Mann, Gottfried Benn and Bert Brecht, prominent scientists like Albert Einstein and Siegmund Freud and actors Heinrich George, Carl Zuckmayr, Joachim Ringelnatz and Asta Nielsen – flocked to tranquil Hiddensee. Author Gerhard Hauptmann, who owned a summer villa there, called the island, with obvious reference to himself, "the most intellectual of all German seaside resorts".

The procession of seaside resorts lining the shores of Mecklenburg-Western Pomerania is a long one. It begins in the west with Boltenhagen and ends in the east with Ahlbeck. Between them lie the island of Poel, the resorts Rerik, Warnemünde, Doberan and Heiligendamm, Kühlungsborn, Graal-Müritz, Dierhagen, Wustrow, Ahrenshoop, Prerow, Zingst, the island of Hiddensee, Göhren, Baabe, Sellin and Binz on Rügen as well as Ückeritz, Kölpinsee, Koserow, Zempin, Zinnowitz, Trassenheide, Karlshagen, Bansin and Heringsdorf on Usedom. On the latter island in the Oderhaff, the "Old Prussians" were brought back from oblivion by making not only Heringsdorf, where they were in the habit of quartering, but also the neighbouring towns of Bansin and Ahlbeck into "Imperial Resorts". Here, we find the famous promenade – famed for the people who strolled along it (therefore called the continuation of Berlin's fashionable Friedrichstrasse) as well as two other highlights to admire: Ahlbeck has the only preserved historic pier and Heringsdorf has the largest, built in 1995, reaching a half kilometre (a third of a mile) into the sea.

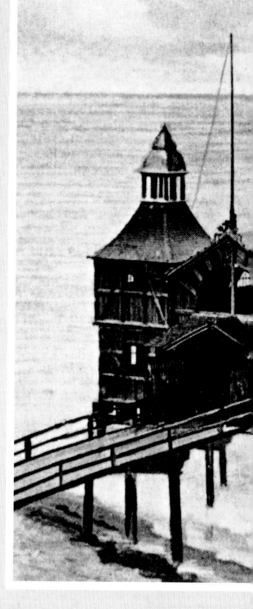

Ostseebad Sel

Left:
The Baltic Sea resort of Brunshaupten in the year 1911. This town was united in 1938 with its neighbours Fulgen and Arendsee to form today's Kühlungsborn.

Above:
The illustration shows the earlier historic pier of Sellin. It was built on wooden pile work and housed both a restaurant and a concert pavilion.

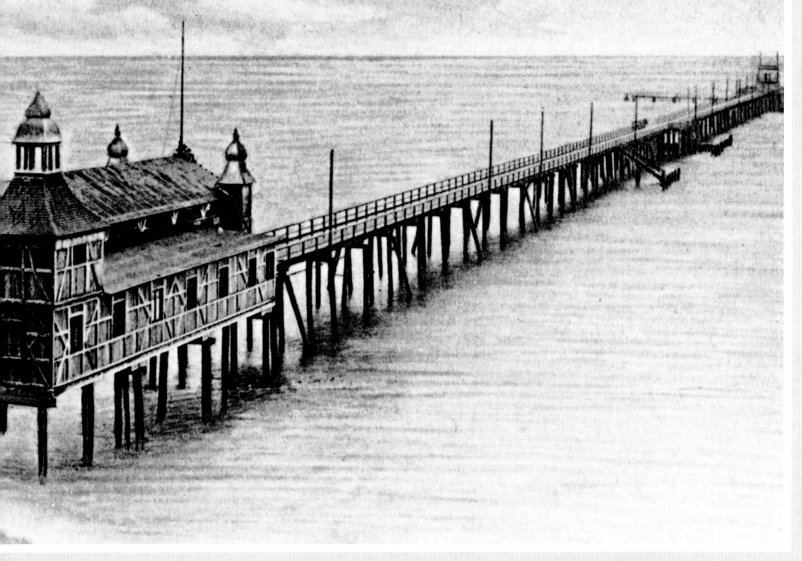

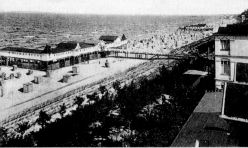

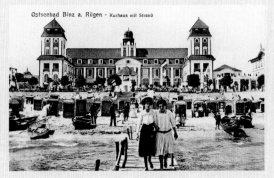

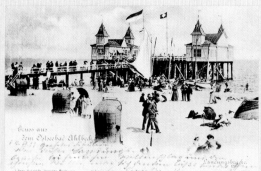

The Baltic Sea resort of ansin showing the romenade in front of he hotels. In those days, he beach was strictly separated by sexes. This photograph shows the family beach and the men's beach.

The old "Kurhaus" in Binz. The poor Rügen fishing village quickly grew to a bathing resort frequented in particular by Berlin industrialists.

"I wish I had gone to Ahlbeck instead!" is the motto of the "Weissen Rössel" (White Horse tavern). This view of the old pier dates from 1899.

71

The Kunstkaten or art cottage, one of the landmarks of Ahrenshoop, is about 100 years old. It was built at the instigation of painter Paul Müller-Kaempff, the man who at the end of the 19th century discovered the poor fishing village and helped turn it into a thriving artists' colony.

Right page:
Fisherman getting his boat ready for the catch. The bright pennants are essential and used to find and secure the nets out at sea.

Ahrenshoop is on the Fischland-Darß-Zingst Peninsula and has many attractions as a Baltic resort, many of them moulded by the sculptors and painters of the former artists' colony. Other tourist magnets are the sandy beach, precipitous coastline and the unmistakable style of building favoured by the inhabitants past and present of Ahrenshoop.

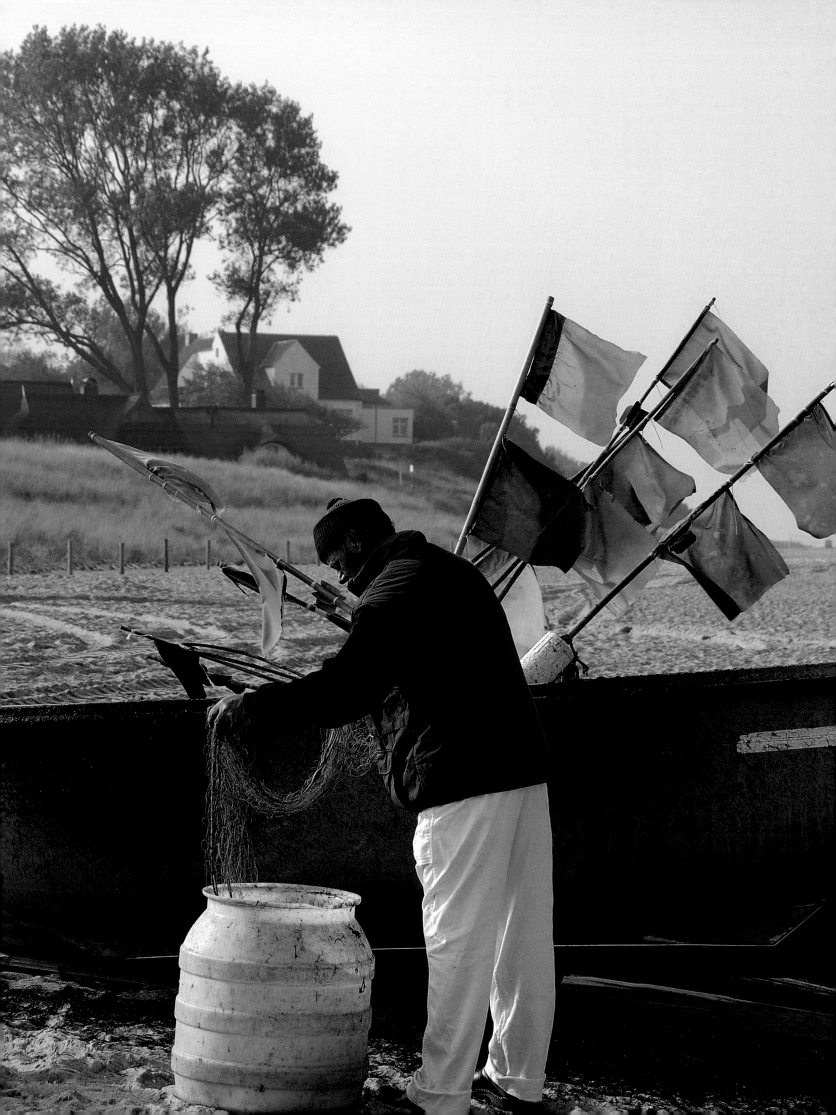

Right:
This photo from Klockenhagen open-air-museum located west of Ribnitz-Damgarten reflects the tranquil rural life that was typical for most of Pomerania and Mecklenburg for many centuries.

Below:
Wolgast, situated on an island on the western shore of the Peene River, originated as a Wend fortress and market town that was granted a German city charter in 1259. The circular medieval Old Town clusters around a small market square with pretty houses.

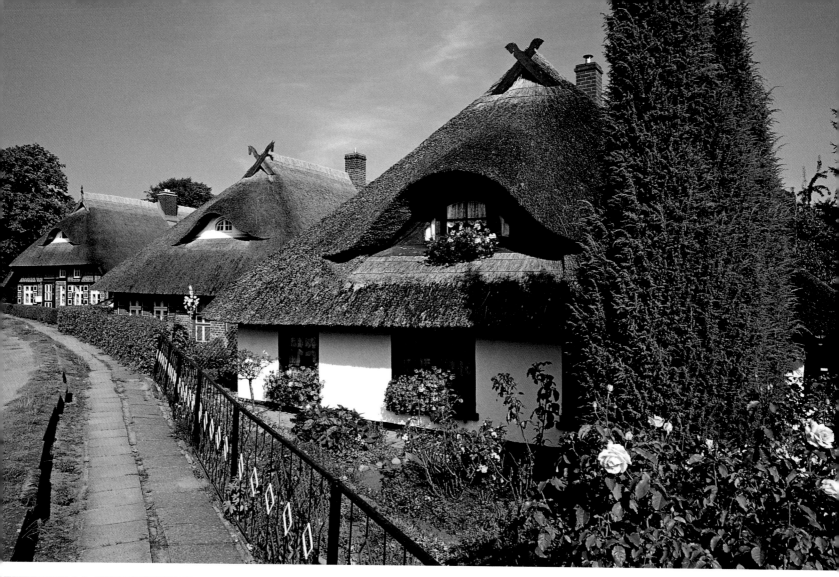

Above:
The quaintness of these old captain's houses in Wustrow – protected as historic monuments – makes one forget that the good old days were not always good. Although the sea was the population's main source of food, it could also drag them to their deaths.

Left:
The little town of Born is hidden between the Darß forest and the Bodden. The fertile fields around it once made it the wealthiest village on all of Darß, as a number of lovely old houses testify.

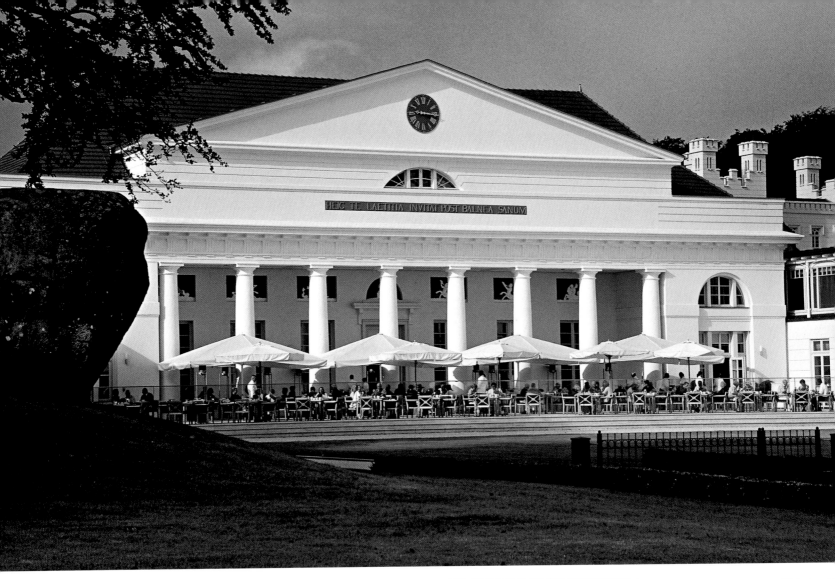

Above:
The old "Kurhaus" is the most handsome and imposing building from the early days of Heiligendamm. Ornamented with Doric columns, the structure was dedicated in 1816 as a "social, dancing and eating hall".

Right:
On the beach at Heiligendamm. These spanking new and very comfortable looking refuges are quite different from the old wooden huts which used to be dotted about the sand.

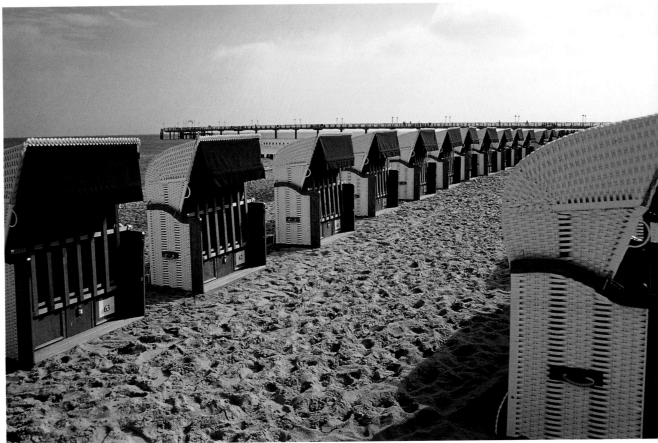

76

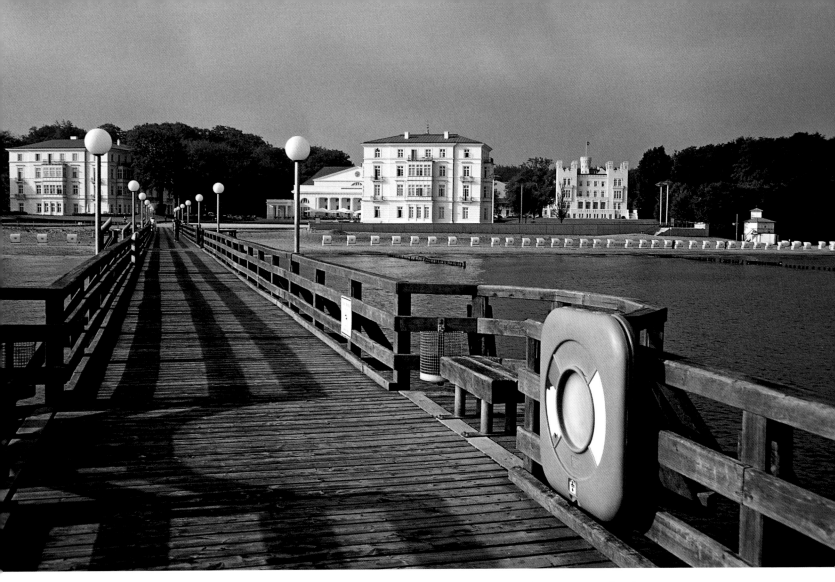

Above:
The neoclassical character of Heiligendamm (and Doberan) is the result of the work of architect Carl Theodor Severin, who was active here for over three decades, from 1802 until shortly before his death in 1836.

Left:
Originally, "Molli" only travelled from Bad Doberan to Heiligendamm during the bathing season. In 1910, the route was extended by 15 ½ kilometres (10 miles) to Arendsee (today's Kühlungsborn West) and began to run all year round.

Right page:
The "Alte Schwede" or Old Swede proudly displays its impressive stepped gable on the eastern side of the Wismar market square. The oldest redbrick townhouse of the city dates from the 14th and 15th centuries and is named after a tavern it housed from 1878.

Despite major damages in the Second World War, the old Hanseatic city of Wismar was able to preserve or rebuild its splendid Old Town. Today, the entire centre of the Old Town is a protected monument.

The twelve-cornered "Wasserkunst" in the middle of the large Wismar market square is more than 400 years old and emulates the Dutch Renaissance style. Until a century ago, it was fed by a spring four kilometres (2 ½ miles) away and supplied more than 200 houses as well as dozens of public watering places in the city.

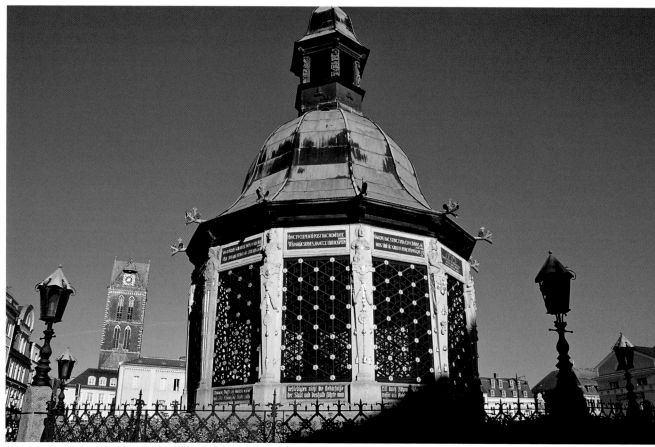

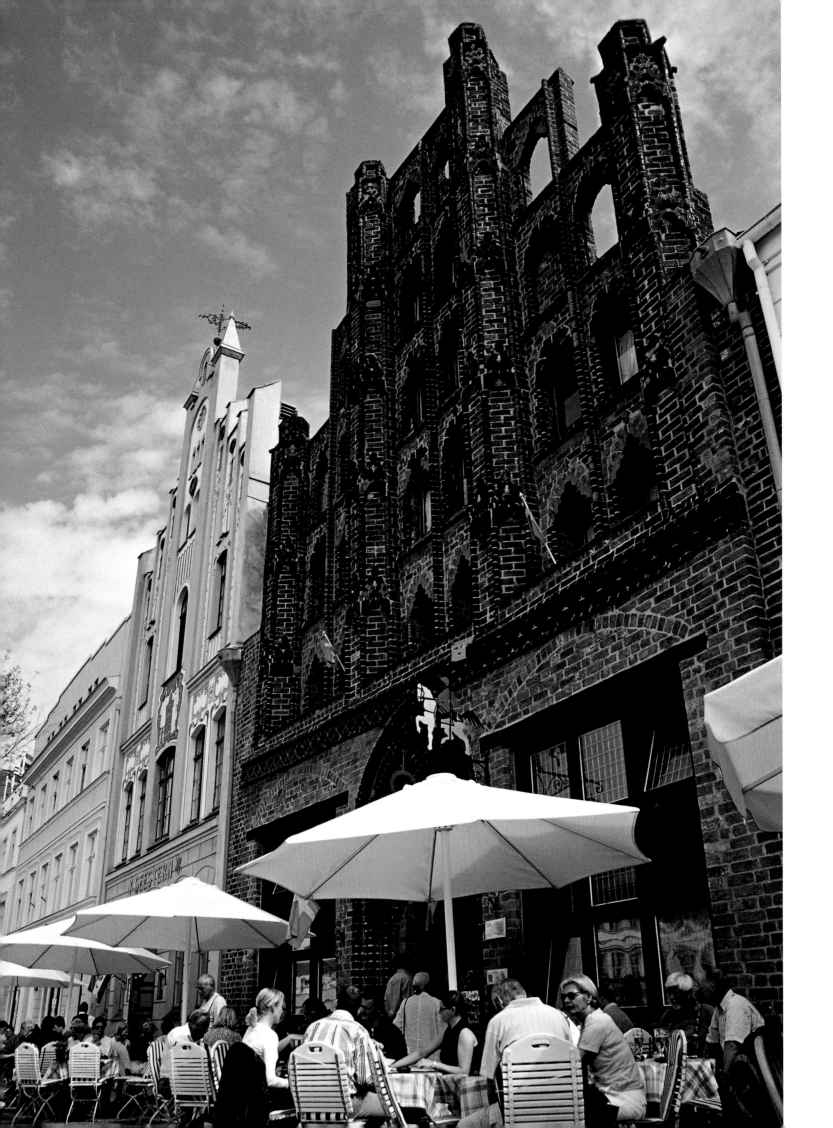

Above:
Once this close to the sea, you should take advantage of what it offers. The best place for fresh fish is right where the trawlers moor, like here in Wismar.

Right:
The cuisine of Mecklenburg-Western Pomerania is more down-to-earth than sophisticated. For centuries, the main aim was just to fill one's stomach. Fish was always one of the staples on the coast. The "Skipper's Platter" serves up cod, pikeperch and salmon.

Page 82/83:
The minster of Bad Doberan, one of the most beautiful brick churches in the region, is embedded in a no less splendid landscaped garden. About 650 years old, the place of worship was once the ecclesiastical focus of Mecklenburg's first monastery and perfectly mirrors the unique architecture of the Cistercians.

Left:
The Baltic Sea and herring have shared a long history, but, as elsewhere, the stocks have decreased here drastically. This fish, preferably served with fried potatoes, will become a rare delicacy in the foreseeable future.

Below:
Of course, here on the coast there are plenty of restaurants with a maritime flair. As long as their food and prices are equally pleasing – like here in Rostock's "Kogge" – the guests are sure to flock in.

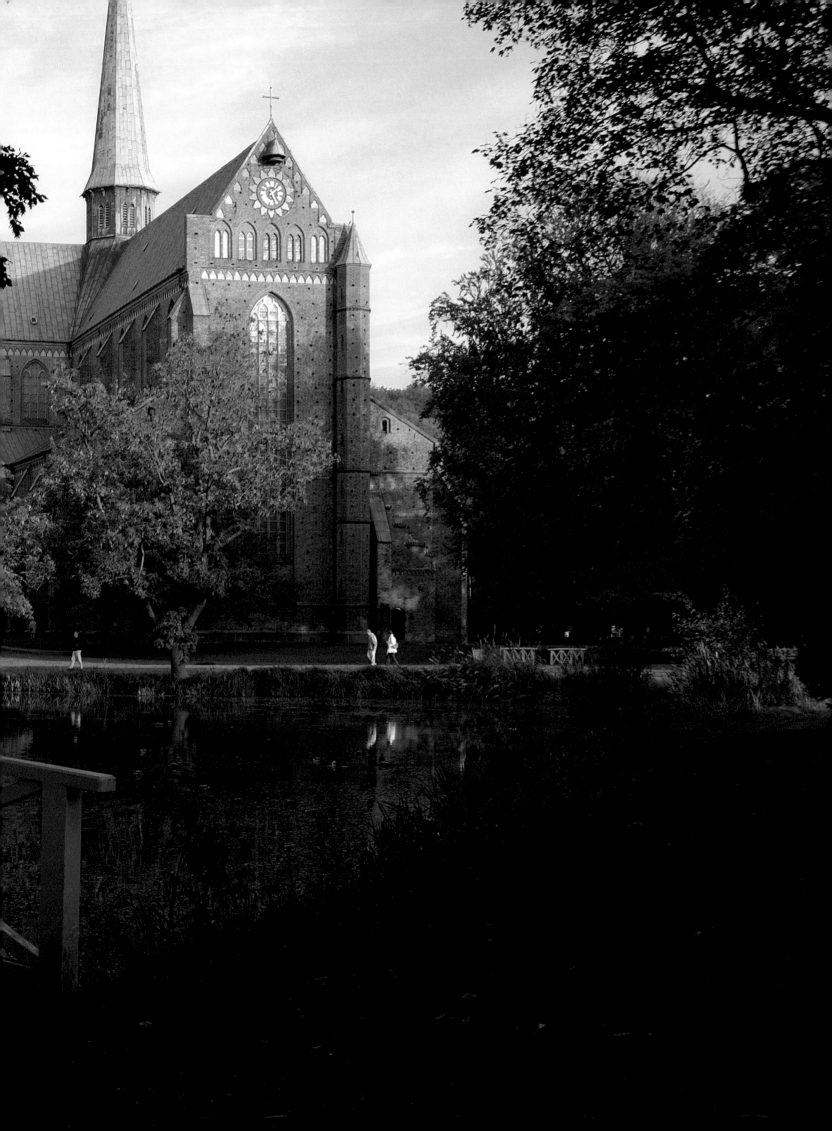

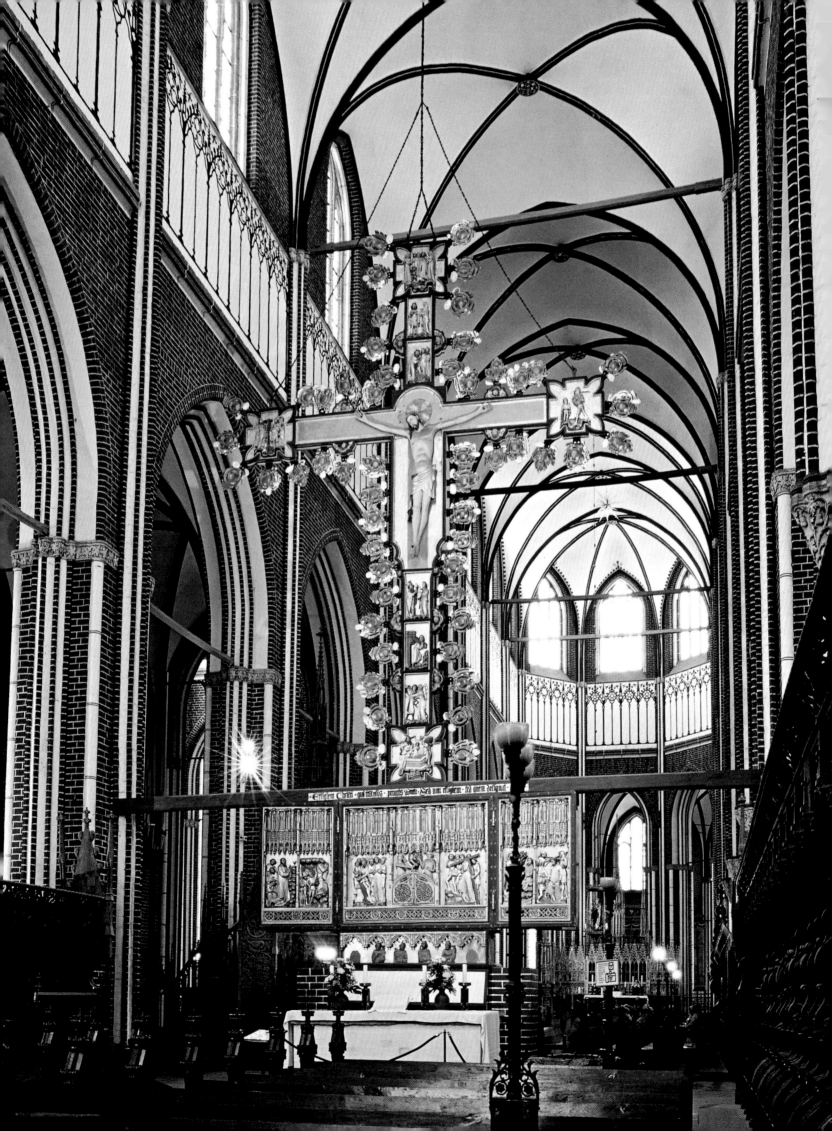

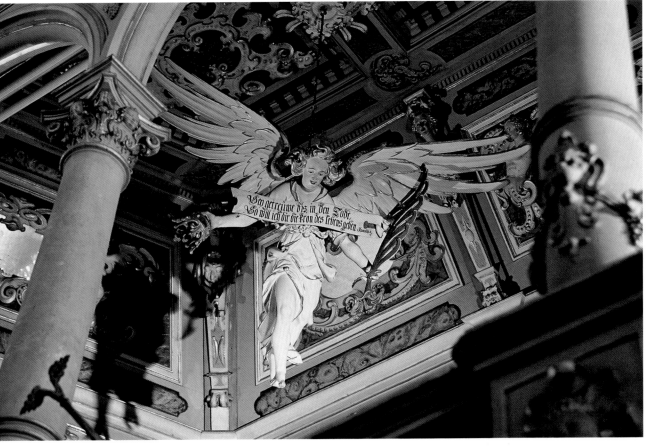

Left page:
What's left of the once wealthiest monastery in Mecklenburg, in Bad Doberan, are the granary, charnel house, brewery and the minster. The triple-nave basilica from the 14th century is one of northern Germany's most outstanding sacred brick Gothic monuments.

Left:
The former monastery church in Bad Doberan was the preferred burial site of the Mecklenburg princes and contains numerous magnificent gravestones and epitaphs. The largest and most splendid are located in the chapels of the choir.

Left:
With a simple brick garment contrasting its richly adorned wooden door, this portal to the Nikolaikirche in Wismar truly beckons one to enter.

Far left:
The Nikolaikirche is Wismar's largest house of worship. Construction of the choir was completed in the late 14th century and the nave about 50 years later. When the tower collapsed during a heavy gale in 1703, the nave was also damaged. Its lovely ribbed vault was not restored until 1867.

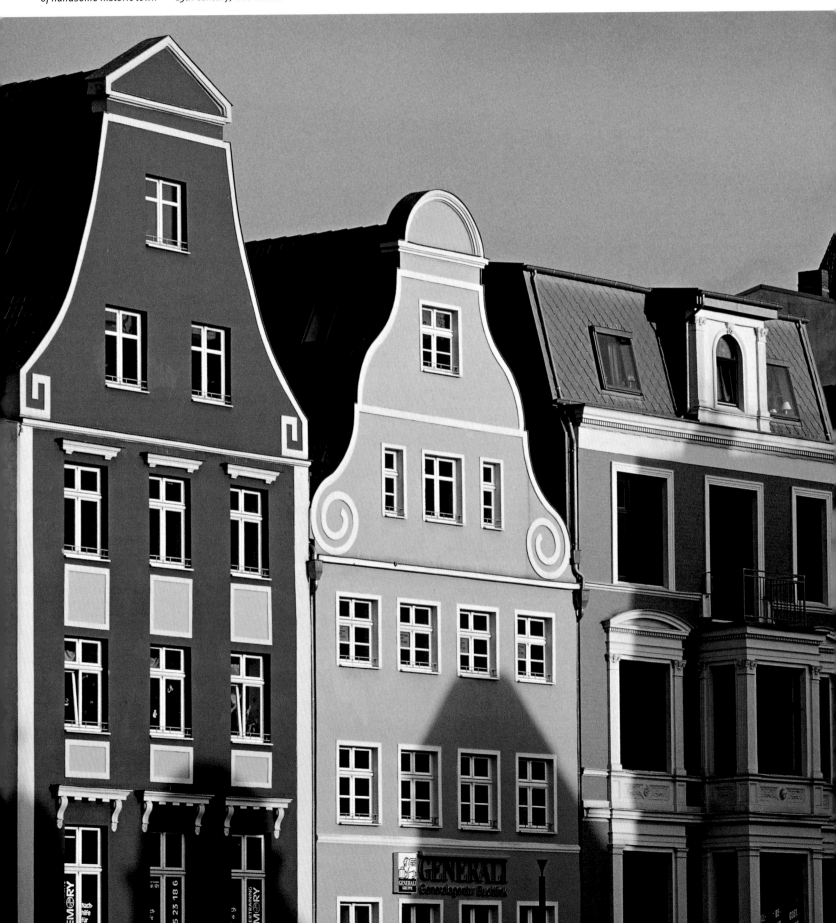

Below:
On the University Square in Rostock. In addition to the ducal palace, a number of handsome historic town-houses cluster around the main building of the "Light of the North", as Rostock University, founded in the 15th century, was called.

Above right:
The dance of gables on Rostock's Kröpeliner Strasse. Here in the pedestrian zone there is a lot to see as well as to buy. The restored old buildings along this esplanade accommodate modern shops.

Centre right:
Rostock's "Rathaus", dating from the 13th century is situated on the eastern side of the New Market Square. The original Gothic brick

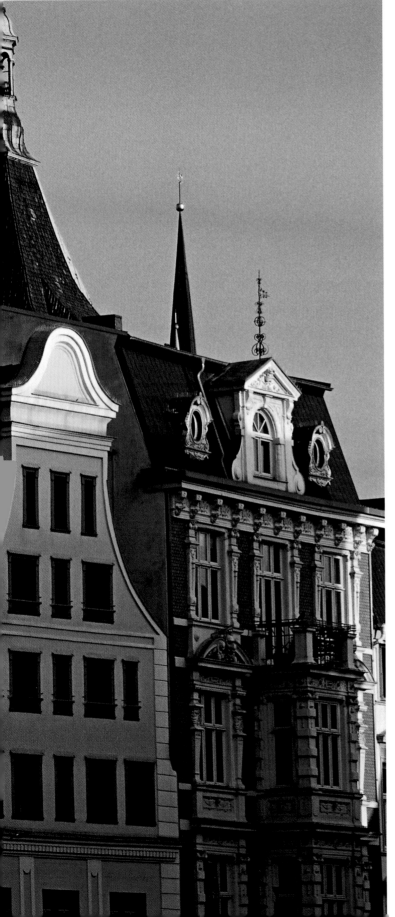

ade of this town hall was most entirely hidden by Baroque portico in 1727, designed by the Saxon rchitect Zacharias Voigt.

Below right:
The Nikolaikirche in Rostock's eastern Old Town dates from 1230, making it one of the oldest hall churches in the entire Baltic region. After being almost completely destroyed in the Second World War, reconstruction of the house of worship was not completed until 1985. Today, it serves as an ecumenical centre.

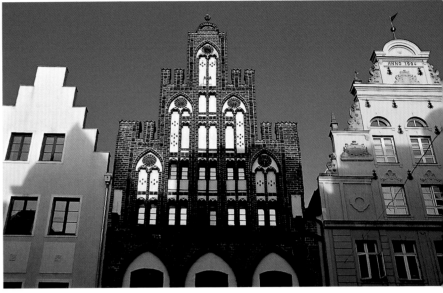

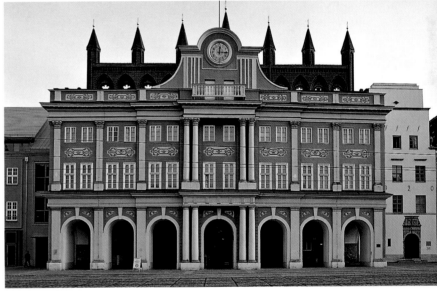

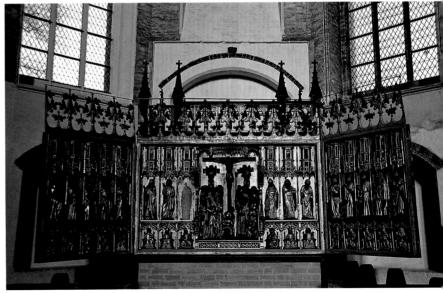

Inspired by sea and sky: Caspar David Friedrich and the artists of the Baltic

Like many who were ahead of their times, Caspar David Friedrich was often punished with criticism or disregard. In 1842, two years after his death, 29 paintings by this man, whose work most purely embodies the ideals of Romantic painting, came under the hammer for a meagre 100 thalers. Even those who appreciated him usually only understood half of what he sought to achieve. The poet Ludwig Tieck confessed that much of Friedrich's nature "remained in the dark" for him. Wilhelm von Kügelgen was one of the few contemporaries to recognize then what the whole world knows today: "Friedrich was a One and Only of his kind." Born on 5 September 1774 in Greifswald, he left his Western Pomeranian homeland after two decades, yet returned for repeated visits and made this landscape a decisive element of his pictorial revolution. The innovation was meant to raise the experience of nature through the spirit and the idea. Friedrich's paintings are therefore not only rich in mood; they are just as rich in symbolism.

One of his most famous paintings is "Chalk Cliffs on Rügen" from about 1818. Friedrich painted the cliffs unrealistically so that one can see both the "Wissower Klinken" and the "Feuerregenfelsen" rock formations. Art historians cannot agree whether the second man in the painting is really the artist's brother. Instead, perhaps Friedrich portrayed himself twice with his wife, as husband and as artist.

The soul of nature

While Friedrich would live to be 65 years old, Philipp Otto Runge, the second outstanding artist of Northern German Romantic art, was granted only half of that time for his life and work. Born in Wolgast in 1777, he died in Hamburg a mere 33 years later in 1810 of con-

sumption. Yet the less than 40 paintings he left behind suffice to make him live on as one of the great artists of German Romantic painting. Like his compatriot Friedrich, he painted "nature and the landscape as the bearer of human ideas and sensitivities, as a mirror of his own emotions" (S. Hinz). His first Romantic painting dates from 1805 (conceived 1801/03) and is called "The Nightingale's Singing Lesson". The nightingale does not appear in the form of a bird, but as a female being bearing the features of Runge's wife, Pauline. The artist's understanding of nature's soul and its allegorical and symbolic message is even clearer in his cycle "Times of Day". He worked on the series continuously and created a number of different drawn versions without being able to paint them – only "Morning" was begun. Yet his portraits are his best-known works. Runge painted his family, friends, and himself, but his favourite subjects were children – such as those of his friend Hülsenbeck or his oldest son – whose psyche he was able to capture like no German painter before him.

Around the turn of the century another artistic innovator made a name for himself in Mecklenburg. Ernst Barlach, born in 1870 in Wedel, Holstein and a resident of Güstrow from 1910, was not only one of the greatest German sculptors, but also a graphic artist, illustrator and writer. Contrasting with his ecstatic dramas full of grotesque characters, his wooden figures turn their gaze inward. The suffering they have experienced makes them demurring and aloof. They appear to concentrate solely on themselves. They are the chastised and the strand-

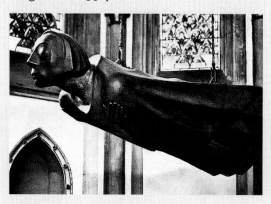

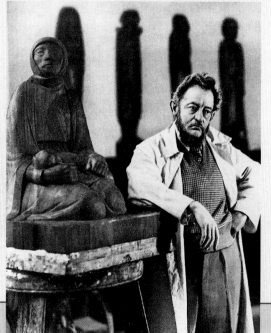

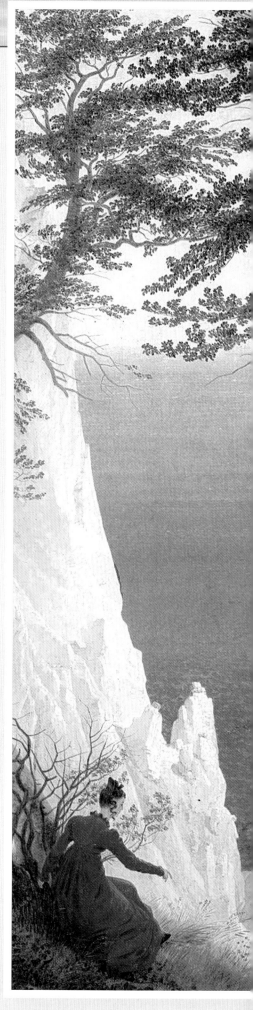

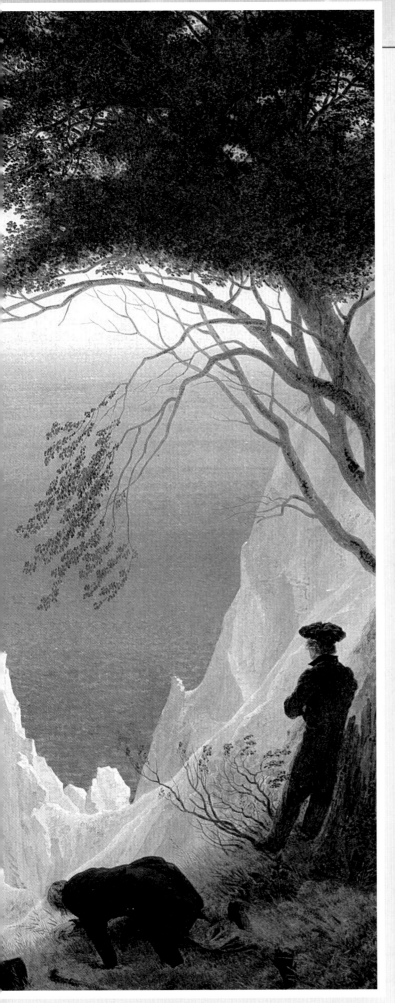

ed – no winners – and by no means members of the "master race". It is not surprising that the National Socialists did not like them or their creator. They labelled him a "cultural Bolshevist" and branded his art as "degenerate". His books were burned and his great monuments in Güstrow (1927), Kiel (1928) and Magdeburg (1929) were confiscated or destroyed. We are left with only a copy of Barlach's famous work, "The Hovering Angel" in Güstrow Cathedral. The works that were preserved are exhibited and those that were lost are documented in the house of his former Güstrow studio, to which a modern exhibition forum was added in 1998.

Centre:
Caspar David Friedrich's famous painting "Chalk Cliffs on Rügen" was painted during the honeymoon of the artist and his wife in summer of 1818, which took them to Greifswald and Rügen.

Left:
Philipp Otto Runge painted "The Hülsenbeck Children" in 1805/1806. In the background, the steeple of St Catharine's Church in nearby Hamburg is recognizable.

Far left:
In 1926/27, Ernst Barlach created this monument to the fallen soldiers of the First World War for the Güstrow Cathedral. Ten years after its dedication, it was confiscated by the Nazis as "degenerate art" and melted down in 1944. The sculpture that can be admired today in the cathedral is a copy from 1952. The second photo from 1937 shows Ernst Barlach in his studio in Güstrow. The following year, shortly before his death, the ostracized artist asserted that he was "not remorseful in the least, let alone reformed".

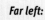

Left:
"Caspar David Friedrich in His Studio" is the title of this painting by his friend Georg Friedrich Kersting, who was born 1785 in Güstrow.

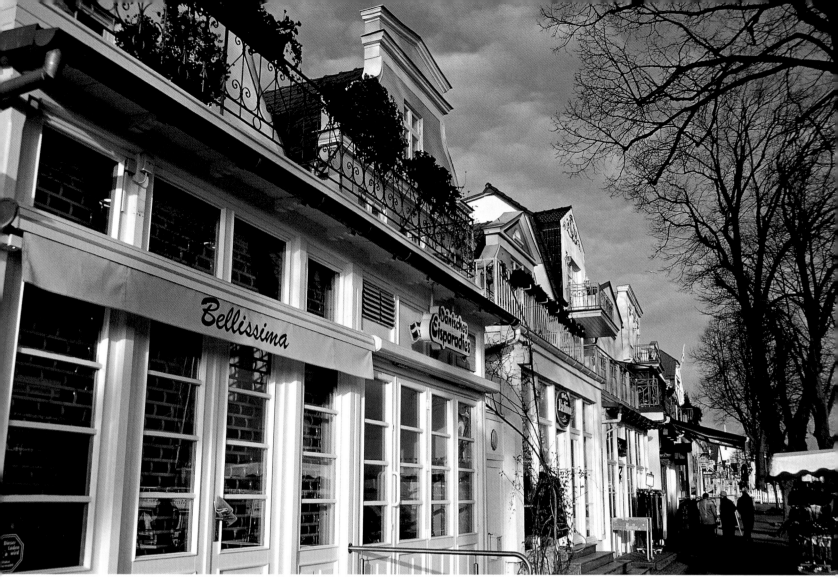

Above:
An entire quarter of old captain's and fishermen's houses has been preserved on the Alter Strom in Warnemünde. The front row on the water was the domain of the more well to do and is therefore especially representative today.

Right:
The second row of houses is on Alexandrinenstrasse. The link between these two parallel streets consists of narrow passageways that could be closed off with doors.

This fisherman's cottage dating from the 18th century on Alexandrinenstrasse is used today as the Warnemünde Local History Museum. It not only documents the hard working and living conditions of the people in olden days, but also the history of the bathing business.

The glass porch typical of the houses on Warnemünde's Alter Strom were described by Theodor Fontane as nothing more than a "glass box", which though "given all sorts of names, whether balcony, veranda or pavilion, still remains a glass box". He added, though, "the existence or non-existence of all guests and, ultimately, of all of Warnemünde depends on it".

Pages 92/93:
Dunes by Warnemünde. The plants on the sand hills help them resist the forces of nature. In addition to beach grass or salt rushes, one sometimes finds rare and therefore protected species such as sea holly and sea lavender.

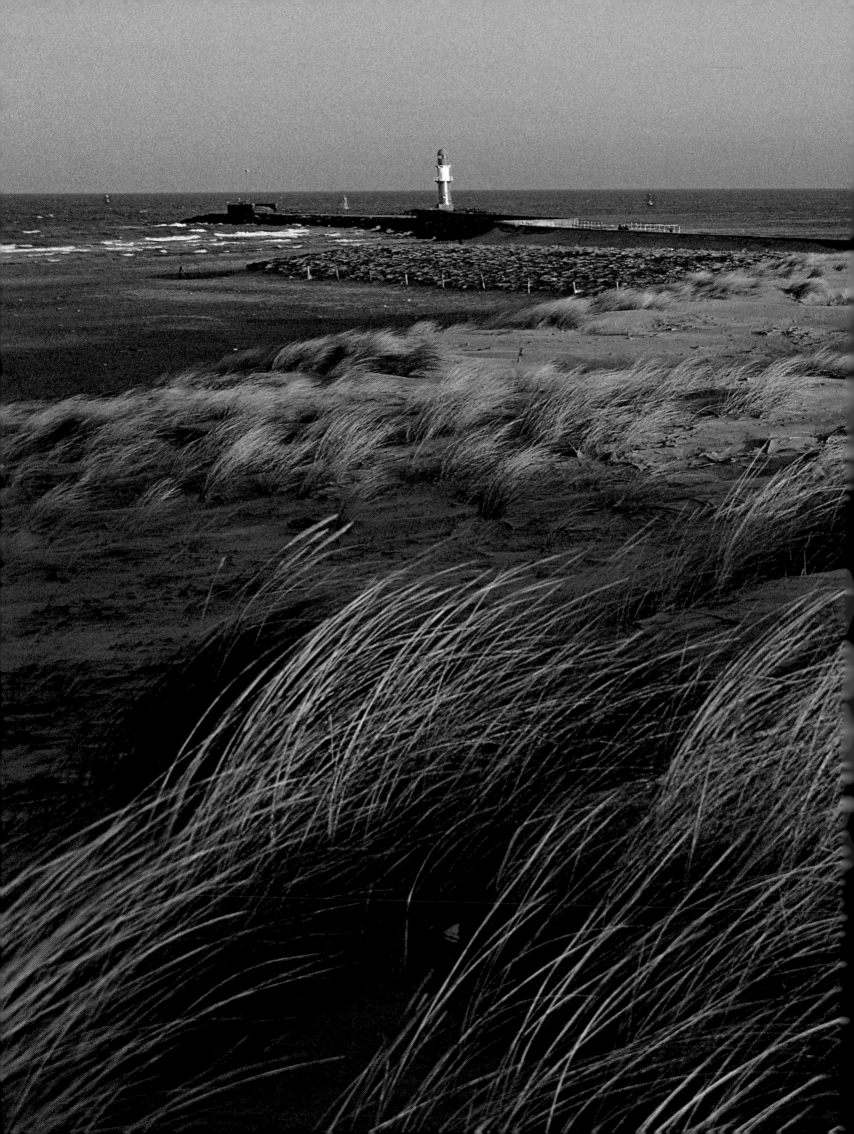

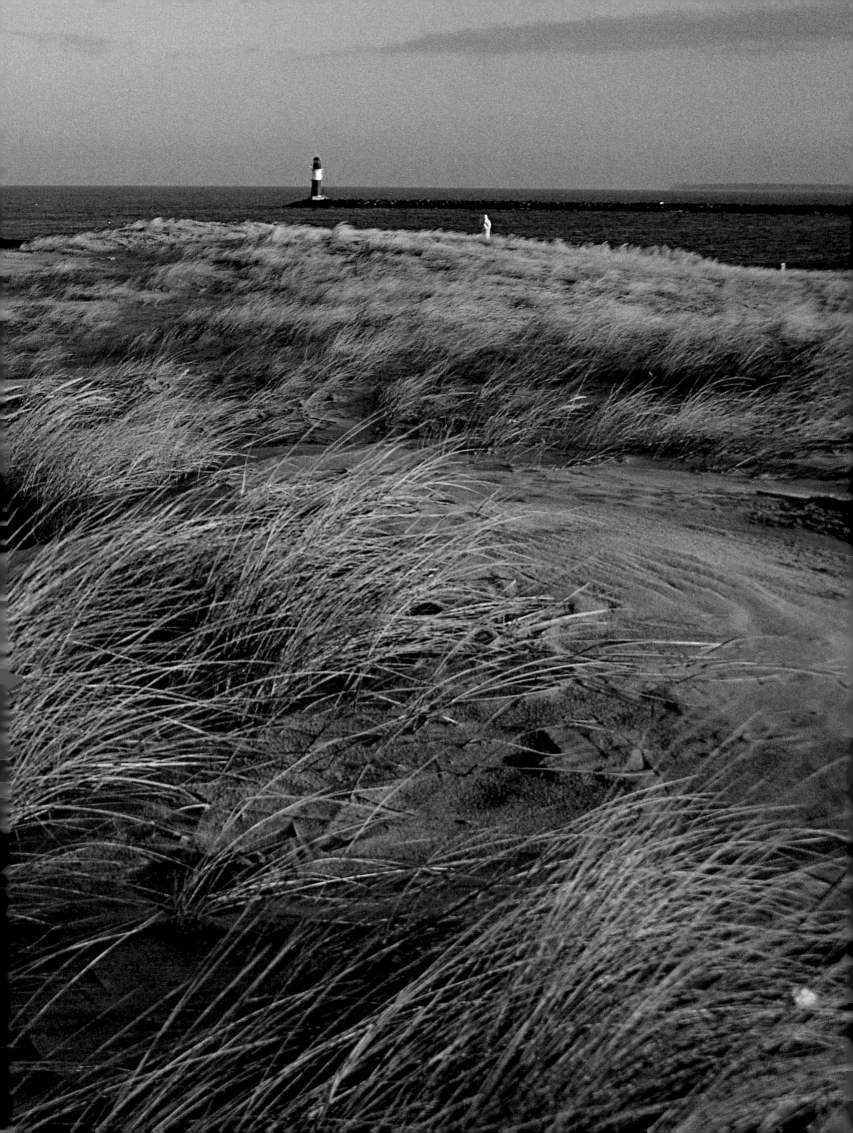

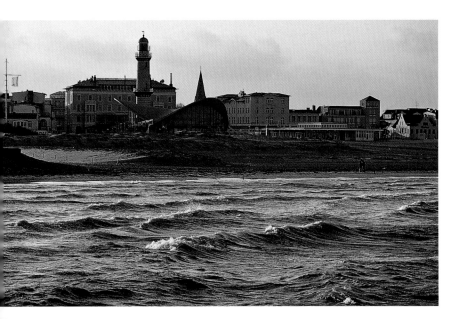

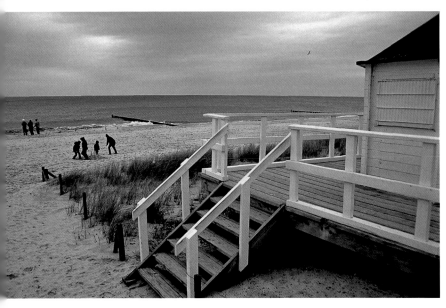

Above left:
The 31-metre (102-foot) high lighthouse of Warnemünde not only serves as a landmark for mariners, but also as an outlook for visitors. The building on its right is not half as old. The concrete construction with the distinctively curved roof dates from the year 1968 and is nicknamed the "teakettle".

Centre left:
A stroll along the Alter Strom of Warnemünde is an opportunity to see the big ferries and cruise

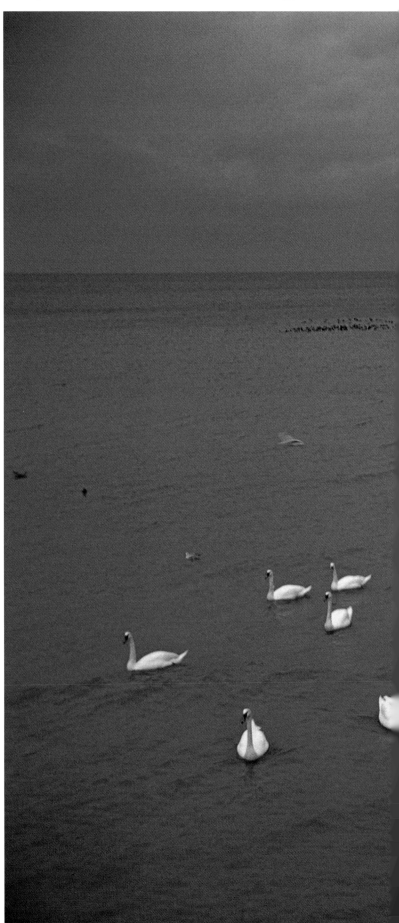

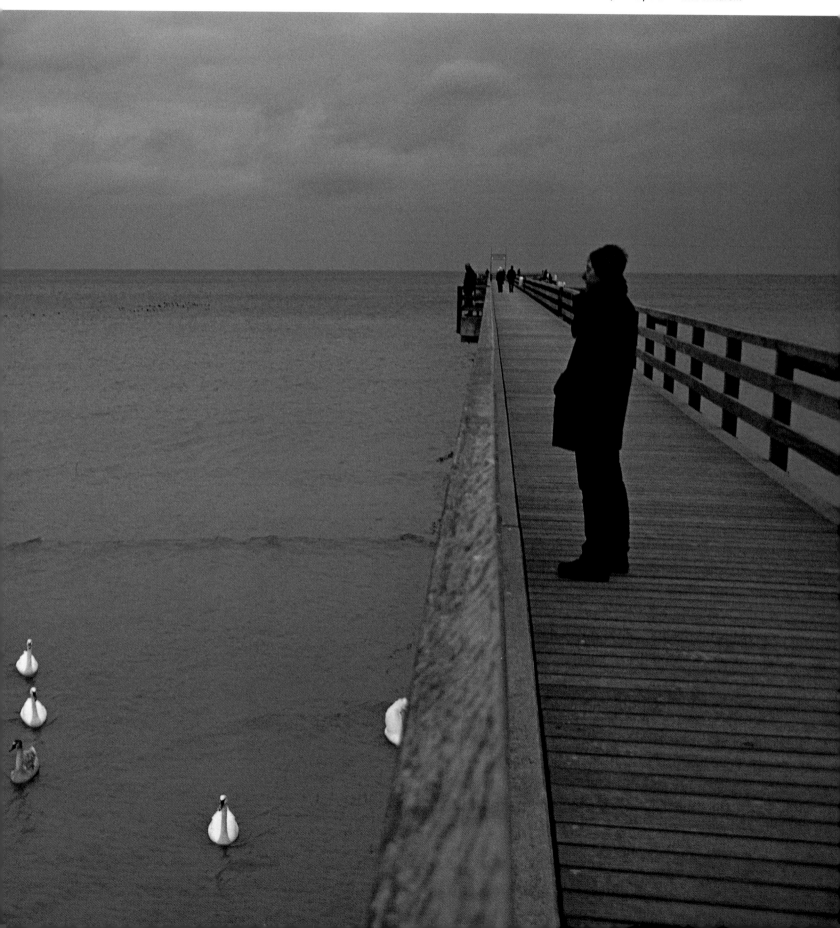

ships as well as all the variety of maritime life – an encounter that might awaken a desire to travel.

Below left:
Kühlungsborn has more than its share of beautiful, broad sandy beaches. In 2002, a new marina was added to make Mecklenburg's largest seaside resort appeal to the great numbers of leisure-time captains as well.

Below:
Boltenhagen, located west of Wismar, is the third-oldest German seaside resort. The old pier, which has been named a protected monument, dates from the industrial age of the early 1870s. The long, flat beach is situated in a protected bay, making it a favourite of families with children.

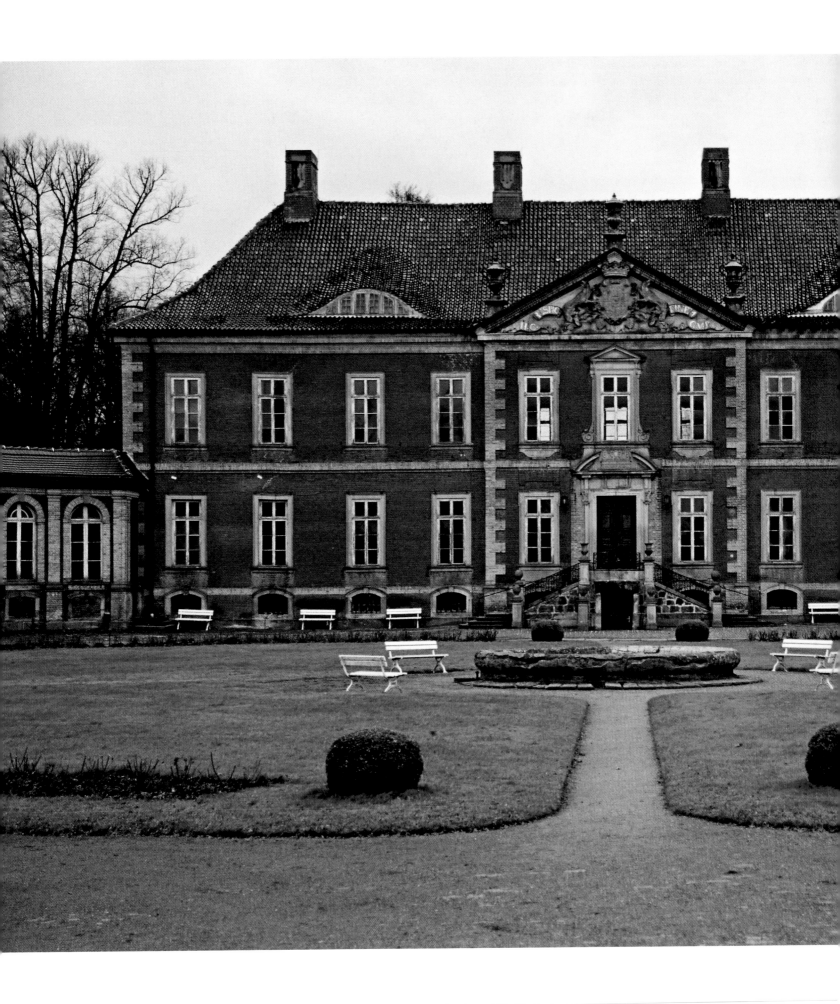

Left:
Schloss Bothmer and its
park are close to the little
town of Klütz at the outer
northwestern edge of
Mecklenburg. The spatial
grounds date from the
days of Imperial Count
Johann Caspar von Bothmer.
The Baroque palace, one
of the most imposing in
all of northern Germany,
was erected in red brick
between 1726 and 1732
and modelled after Blen-
heim Castle in Oxfordshire,
England. During the summer
months, it is also used as a
concert and festival venue.

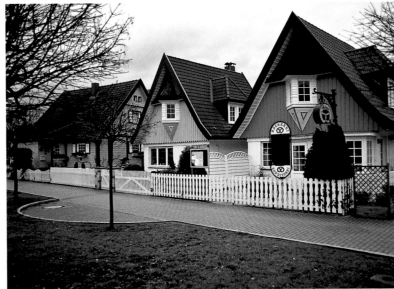

Above and top:
The suffix "hagen" denotes
a forest and its clearance,
while the prefix refers to
a man named Bolten, who
must have founded the
town. Boltenhagen was first
mentioned in a document
in 1336. Since then, much
time has passed and
the sleepy fishing village
has become a bustling
swimming resort. Five old
Low German "hall houses"
have survived the passage
of time here and newer
buildings are adapted to
the regional style.

Between the dunes and the lakes – the inland

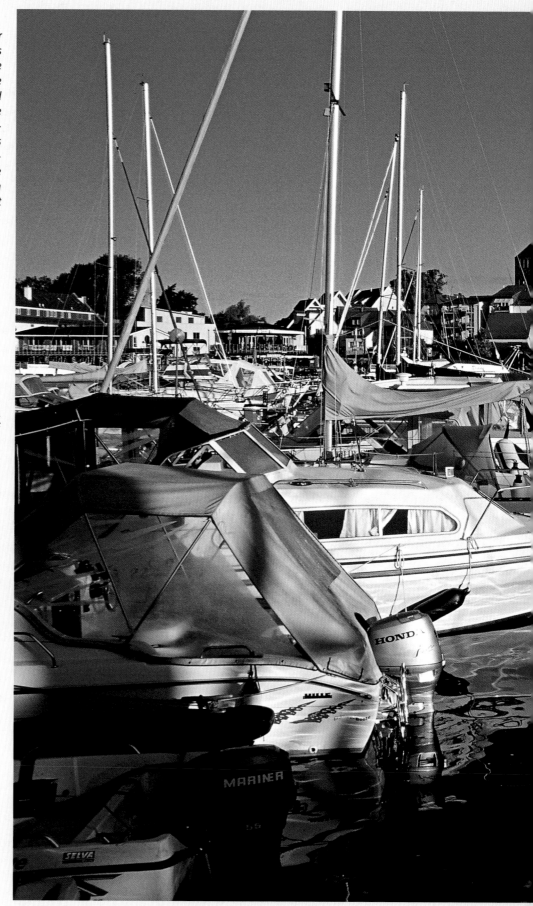

Mecklenburg-Western Pomerania may be flat, but it is by no means dull. Directly behind the shimmering white sand, we see the glow of golden grain and yellow rapeseed, recalling the days when Mecklenburg was Germany's unrivalled granary and potato cellar. We see the trees lining the roads, and then further inland they form forests creating a green fringe about the fields, meadows, villages and small towns.

These forests range far to the south where they meet a gently rising chain of hills upon which they – by local standards – nearly rise to the skies. Mecklenburg's Switzerland may lie somewhat off the course of the great streams of tourists, but reasons to journey here are provided by Barlach's Güstrow, Fritz Reuter's Stavenhagen and Heinrich Schliemann's Ankershagen, by the thousand-year-old Ivenack oaks, the lakes of Malchin and Kummerow as well as Neubrandenburg's brick city gates and guardhouses.

From a purely geographical point of view, Mecklenburg's Switzerland dances rings around the Mecklenburg Lakeland. The tourists, however, favour the latter, thanks to the large realm of waters ruled over by Lake Müritz. Covering an area of 117 square kilometres (45 square miles), Müritz is surrounded by over 1,000 lakes and ponds. For both natives and visitors, this lake is a sea – and its size is best admired from the tower of the Marienkirche in Röbel.

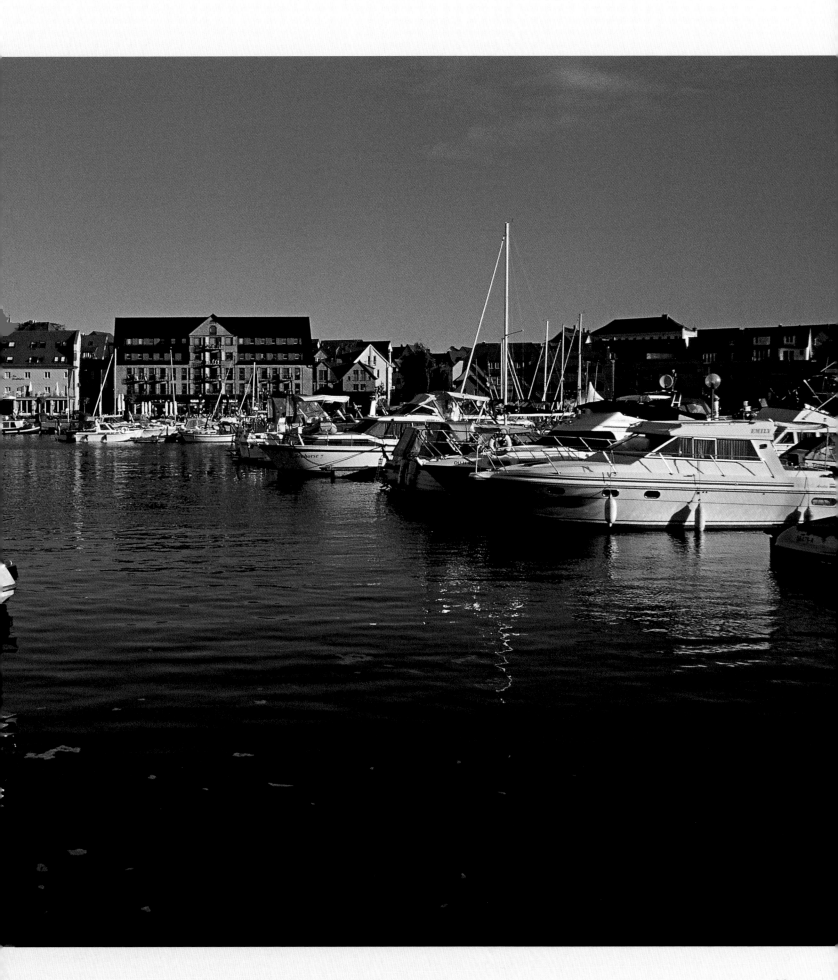

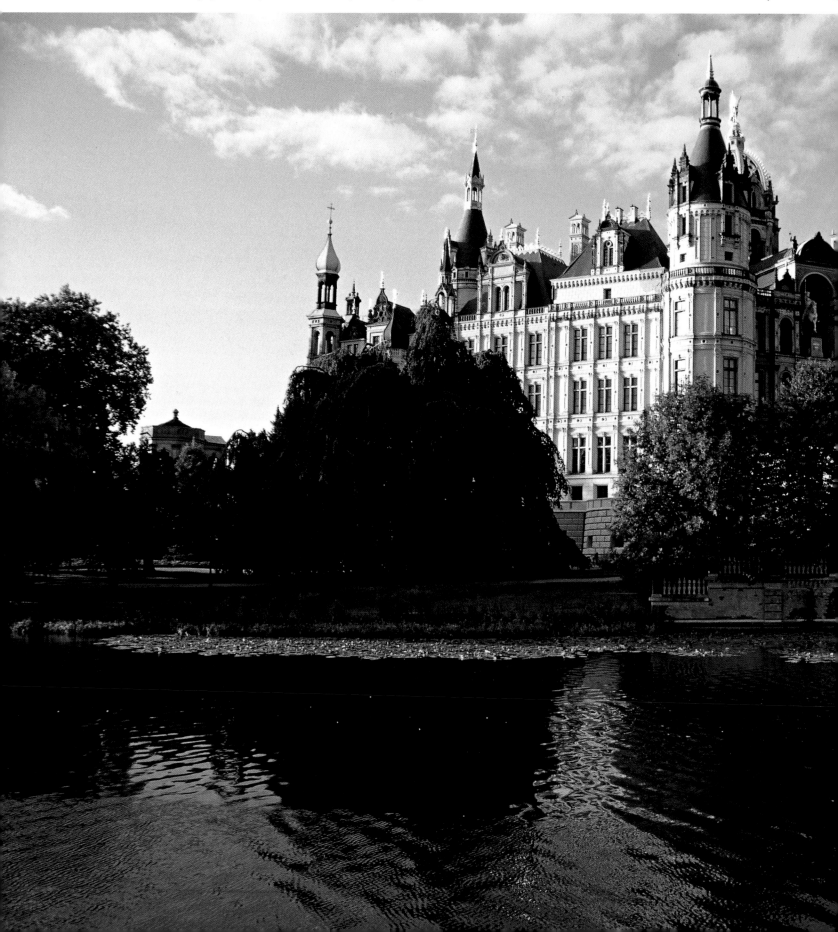

Above rig[...]
Before court archit[...]
Georg Adolph Demm[...]
and his chief engine[...]
Hermann Willebra[...]
began reconstruction[...]
Schweriner Schloss in 18[...]
they undertook stu[...]

Below:
The castle of Schwerin was built as an irregular pentagon on an island measuring only 150 metres (about 500 feet) in diameter. The island in the southwestern bay of Lake Schwerin is connected to the city and the castle gardens by bridges.

Centre right:

vels to France and Great
tain. Chateau Chambord
on the Loire must have
scinated them in partic-
ular. The photo shows a
magnificent cupola
crowned by an angel.

Centre right:
When you walk from the
city to Schweriner Schloss,
you are greeted on the
bridge by this horse tamer
and a colleague on high
pedestals, sculpted
by Christian Genschow
from 1874 to 1876.

Below right:
Similar to its famous
French prototype, special
attention was paid to
the roof landscape of
Schweriner Schloss. The
labyrinth of towers, roofs
and gables offers ever new
and surprising sights.

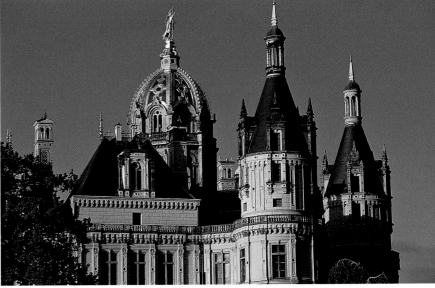

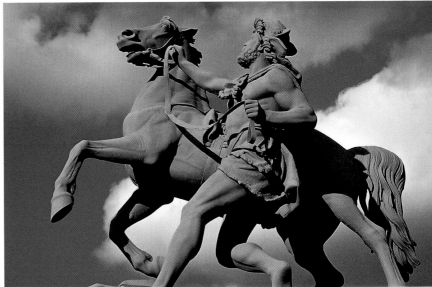

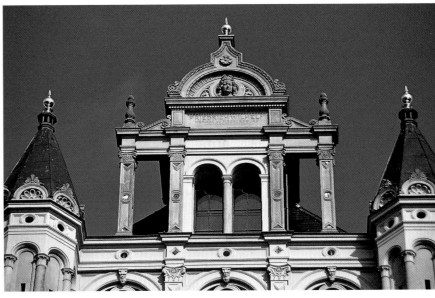

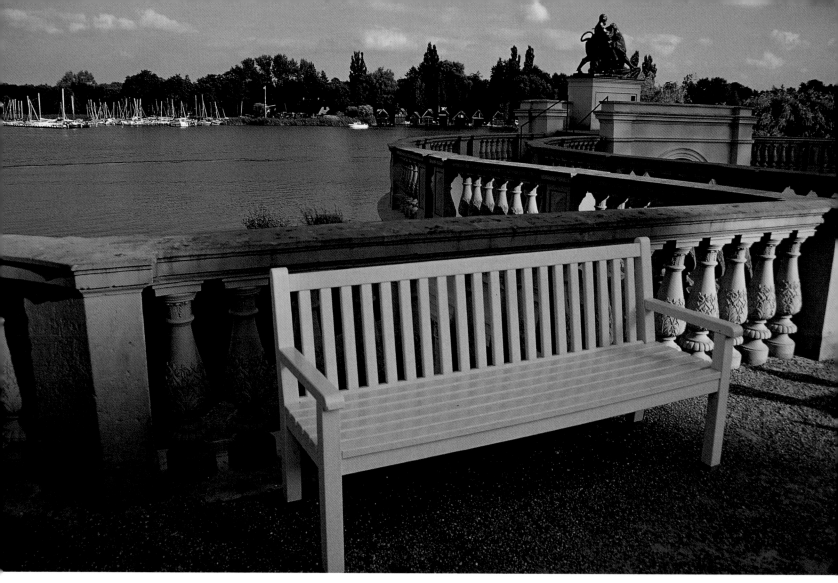

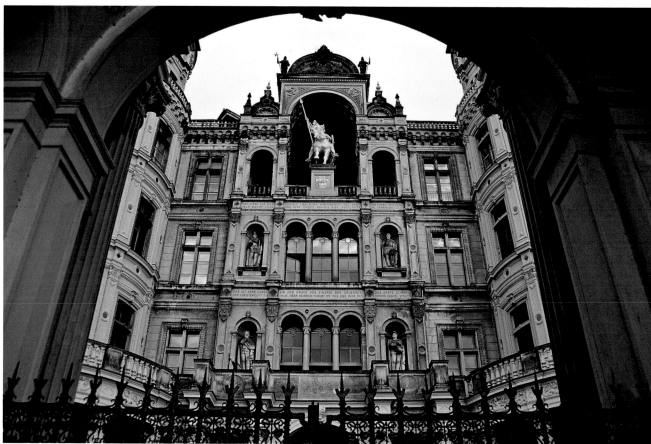

Above:
The castle garden offers a lovely view across Lake Schwerin. The garden, which dates from the reconstruction of the castle, was recently restored. Court gardener Theodor Klett used sketches by Gottfried Semper and Peter Joseph Lenné for its design.

Right:
View into the courtyard of the Schweriner Schloss. Once reconstruction was completed, Grand Duke Friedrich Franz II and his wife Auguste moved into the castle chambers on 26 May 1857. The richly ornamented throne room with the throne dating from 1750 is the castle's highlight.

Left:
From 1883 to 1886, the Mecklenburg State Theatre of Schwerin was built by Georg Daniel using a blend of the Neo-Renaissance and Neo-Baroque styles. It stands on the site of the previous theatre, which burned down in 1882.

Below:
View from the Schweriner Schloss to the historic city. The theatre is across the bridge and, to the left, the cathedral steeple towers above the city.

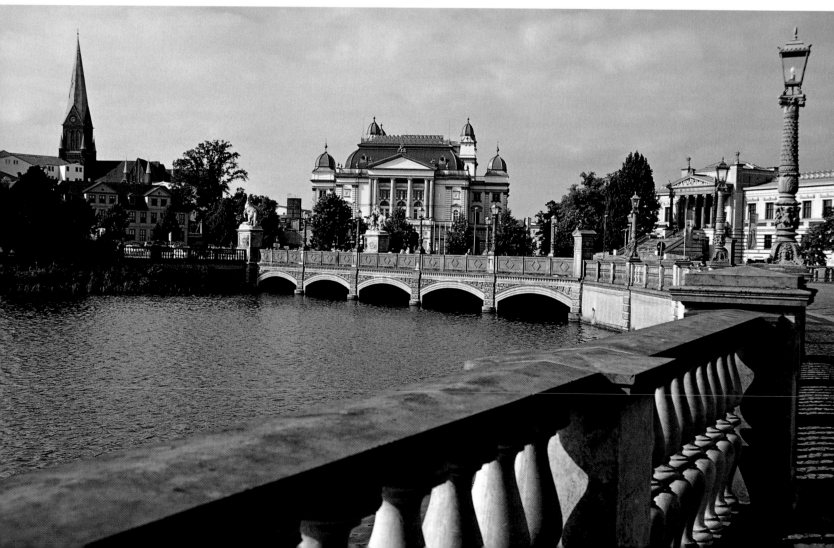

t:
 north side of the
 Town market square
Schwerin is dominated
the so-called "Neue
bäude" (New Building).

Behind the neoclassical
façade and its 14 Doric
columns is a former
market hall, built in the
late 18th century.

Below:
From 1705, a new quarter
was erected in Schwerin
called "Neustadt auf der
Schelfe". Many of the

original half-timbered
eave-roofed houses
from the Baroque age
have been preserved
and restored.

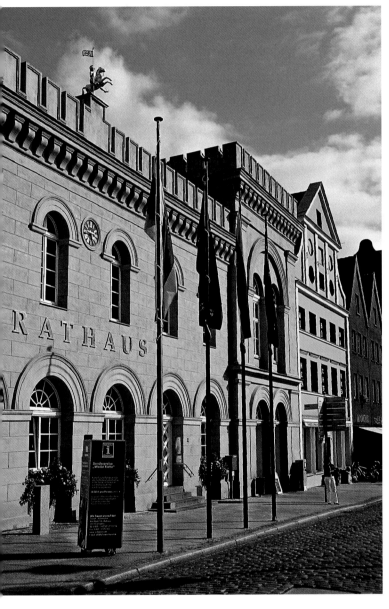

t:
 ly its name reminds
 of the former purpose
the Schwerin Butchers'
rket, no more than a
ne's throw from the
vn hall.

Above:
The "Rathaus" in Schwerin's
Old Town dominates the
east side of the market
square. First documented
in 1351, in 1834/35 it was

given a Tudor Gothic
façade planned by Georg
Adolph Demmler, the
architect of the castle and
many other buildings in
the city.

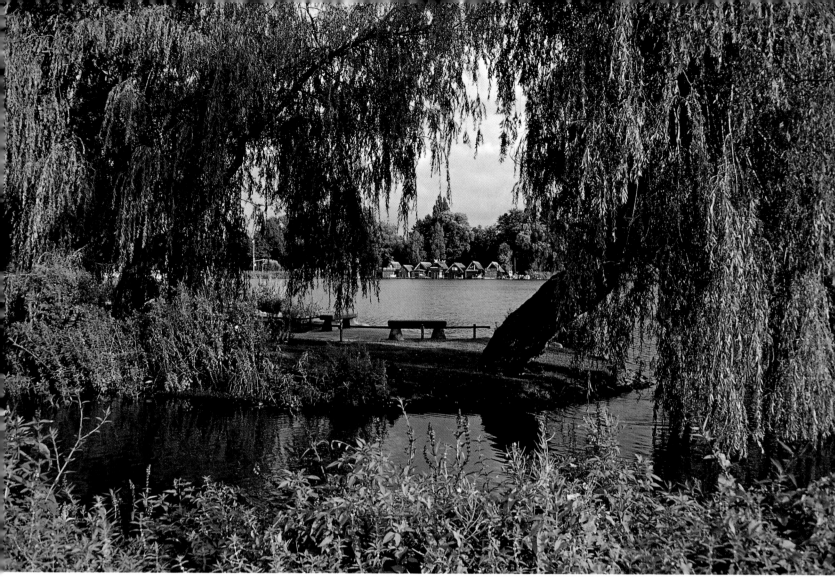

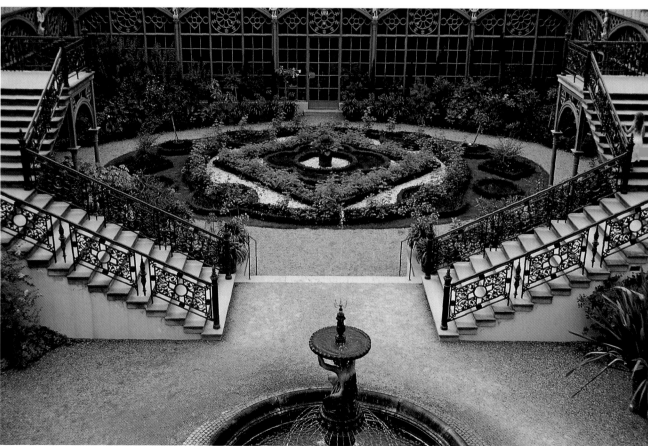

Above:
Their name sharing reveals the close relationship between Lake Schwerin and Mecklenburg-Western Pomerania's state capital. Both natives and the many visitors profit from their romantic encounters.

Right:
Since the huge Schweriner Schloss took up most of the limited island terrain, there was not much space left for the castle gardens. Its architects solved the problem by distributing them over terraces linked by stairways.

Lake Schwerin, which runs almost exactly north-to-south, covers over 60 square kilometres (24 square miles) and is the second-largest inland water in Mecklenburg-Western Pomerania. Due to its proximity to the state capital, it is a well-developed lake.

OF LOW AND HIGH GERMAN

The language spoken in the lowlands of northern Germany is called "Plattdeutsch", which arose from Old Saxon and Middle Low German. Although Low German is spoken today only at home, it influenced other languages of peoples surrounding the Baltic and North Seas. Danish, in particular, borrowed a number of Low German words from contact with the traders of the Hanseatic League. With the decline of the league, Low German declined as well.

The most widely read German author of the 19th century wrote his books in the "Plattdeutsch" dialect of his homeland. Fritz Reuter was born in 1810 in Stavenhagen, which he was forced to leave at the tender age of 26 by order of the Berlin Supreme Court on the charge of "participating in high treason in a students' duelling society". The death sentence was commuted to 30 years fortress imprisonment, seven of which he served. He served the last years in Dömitz fortress, where he was amnestied on the authority of the Grand Duke of Mecklenburg in 1840. He then wandered about aimlessly, but eventually steadied himself with his writing. His successful career began with "Manuscript of a Novel" – not printed until 1930 – the original High German version of his later major work "Ut mine Stromtid" (During My Apprenticeship) whose protagonist proved to be a fearlessly critical analyst of contemporary times. Yet Reuter was not only a man with a marked sense of social responsibility, but also a gifted humorist who drew fully from the life of the common people – sometimes crudely, sometimes phlegmatically.

What Reuter was for Low German prose, John Brinckmann (born 1814 in Rostock) was for poetry. Besides the famous skipper's tale "Kaspar-ohm un ick" (1855) set in his hometown, his sea chanteys, romances, fables and children's songs are classics in the repertoire of Low German verse.

Ernst Moritz Arndt made a name for himself with his powerful, popular lyrics. Born in 1769 on Rügen as the son of a former serf, Arndt was one of the most significant political pamphleteers and patriotic poets of his times. His anti-Napoleonic and democratic convictions led to persecution, loss of his professorship and imprisonment. His most famous song was "God, who gave iron".

The literary ancestor of all Mecklenburg lyricists was Prince Witzlaw III of Rügen, who made a name for himself around 1300 as a minstrel and the originator of the candid declaration: "Greater bliss (than love) I have not known!"

The 20th century gave Mecklenburg-Western Pomerania four significant authors of the most diverse types. Hans Fallada was born 1893 as Rudolf Ditzen in Greifswald. In 1933, after the world success of his novel "Little Man, What Now?", which was translated into 20 languages, he bought the country estate of Carwitz, where he lived and worked until after the end of the Second World War. Ehm Welk from Uckermark, who moved to Bad Doberan in 1950, reached similarly high sales. His novels "The Heathens of Kummerow" (1937) and "The Righteous of Kummerow" (1942) are among the most successful books of their time. Born in 1934 in Pomeranian Cammin, Uwe Johnson lived in Güstrow before leaving the GDR in 1959. His books, written in a modern structure and language and therefore not easily grasped, take Germany's division and its tragic consequences for the people as their subject matter. From his first novel "Speculations About Jakob" (1959) to his final, four-volume tour de force "Anniversaries: From the life of Gesine Cresspahl", completed a year prior to his death in 1984, references to the localities and motifs of his former homeland are unmistakable. Walter Kempowski, who died in 2005, was the most famous contemporary author from Mecklenburg-Western Pomerania, best known for "Tadellöser & Wolff" and his chronicle of the Second World War "Echolot" (Echo Sounder). After the fall of the Berlin Wall he donated his archives to his native Rostock. These now form the basis of a small memorial museum housed in the Kloster zum Heiligen Kreuz, once a monastery.

We have not forgotten Gerhart Hauptmann. Although he spent many a summer on his "sweetest isle" of Hiddensee, both his life and works do not belong to Mecklenburg-Western Pomerania, but to Silesia.

Above:
On Hiddensee, Gerhart Hauptmann found the maritime summer counterpart to the mountains of his Silesian homeland. His "Haus Seedorn" in Kloster today accommodates a highly frequented memorial museum.

Left:
In 1924, Thomas Mann took up quarters in this "Haus am Meer" on Hiddensee. While on the island, he paid visits to Gerhart Hauptmann and welcomed Albert Einstein.

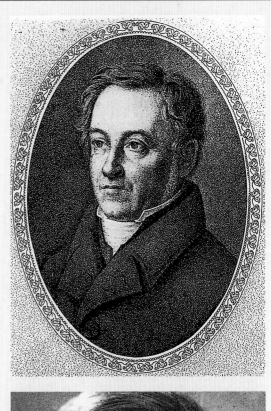

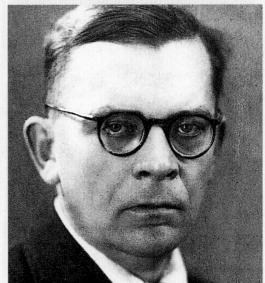

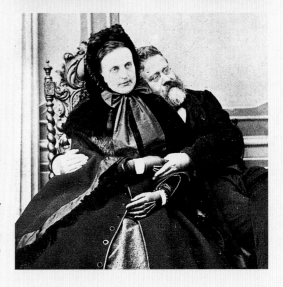

Top right:
Ernst Moritz Arndt dedicated all the forcefulness of his personality as well as his publishing and literary creativity to the Anti-Napoleonic Wars of Liberation.

Centre right:
The Mecklenburg-Western Pomeranian phase of Hans Fallada's eventful life includes the episode when the Soviets appointed him mayor of the small town of Feldberg after the end of the war.

Right:
This picture from 1860 shows Fritz Reuter with his wife Luise. At this time, the poet and his family resided in Neubrandenburg (1856–1863), from where they later moved to Eisenach.

Below:
The interesting historic heritage of Neubranden-burg includes the many guardhouses, which were built at intervals into the city walls and served the citizens' defence.

Below:
Treptow Gate, ornamented with a stepped gable and blind tracery is the highest of the four Gothic brick gates of Neubrandenburg. The four-storey construc-tion, erected about 1400 and used today as a museum, towers 32 metres (105 feet) to the skies.

Rig
The Stargard Gate
Neubrandenburg da
from the mid-14th centu

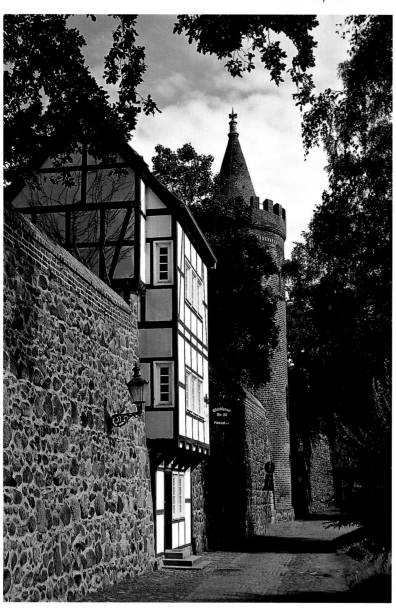

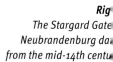

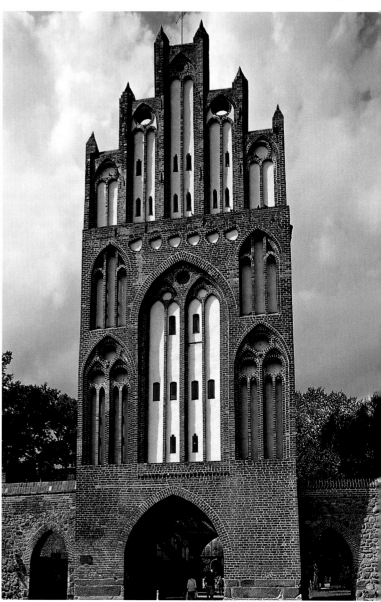

Right:
The main attractions of the New Gate are another nine over-life-size female figures, not made of stone

but of terracotta. The g
tower is three store
high and was erected
the second half of t
15th centu

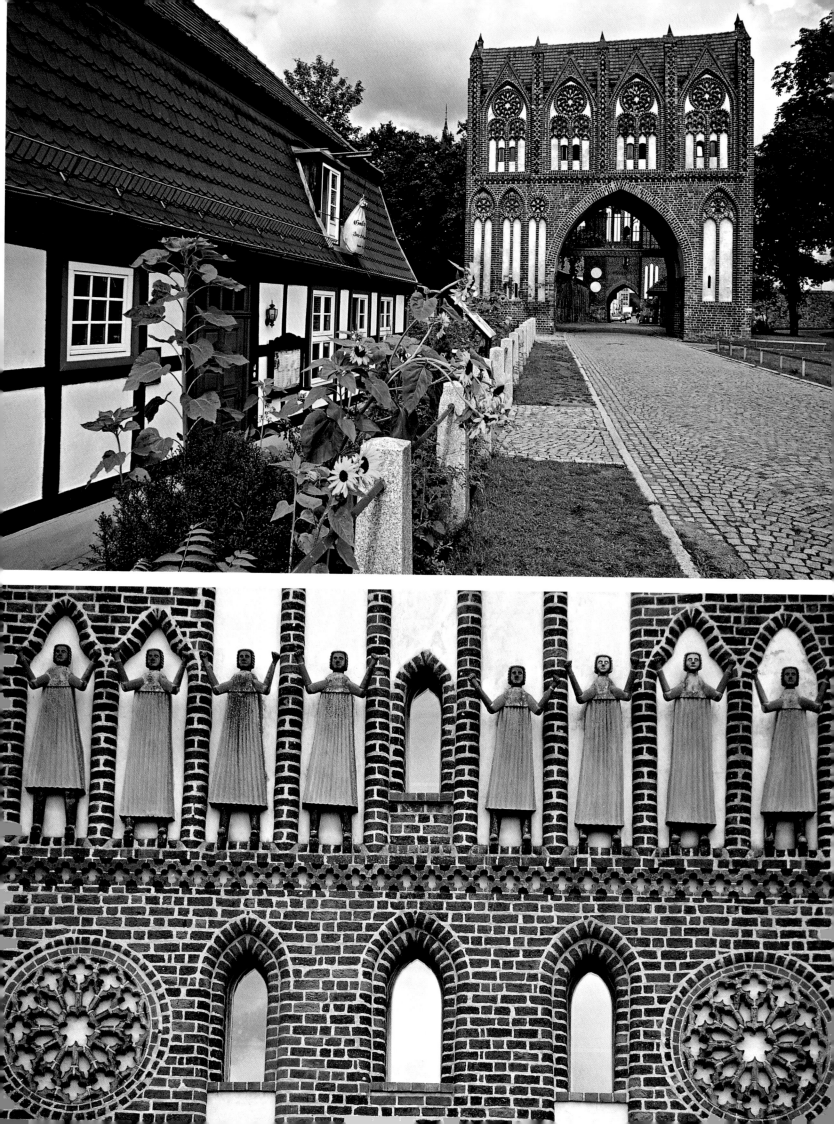

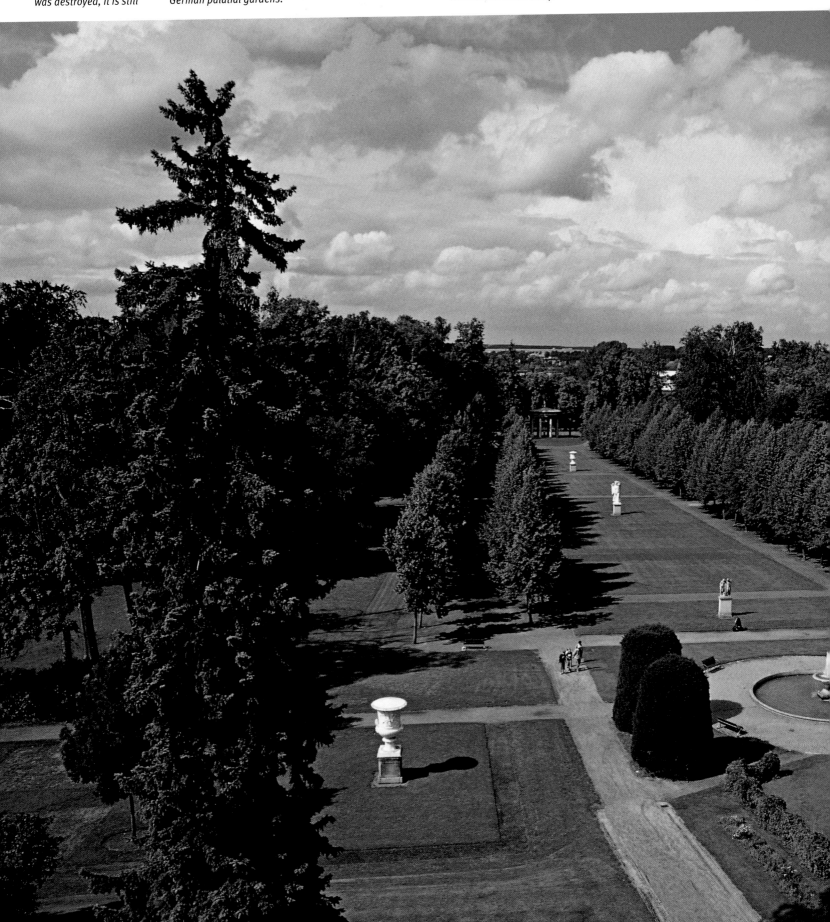

Below:
Although the centrepiece of the park of Neustrelitz was lost when the palace was destroyed, it is still well worth a visit. It was opened to the public in the early 19th century; far earlier than most other German palatial gardens.

Above right:
As early as 1842, Grand Duke Georg put the Orangerie to a different use: as a garden salon, it assembled his collection of antiquities. Copies of Roman and Greek sculptures and frescos on the walls and ceilings depicting scenes, for example, from ancient Pompeii, give the café housed there now a very special – neoclassical – ambience.

Centre right:
Only nine of the original 22 sculptures in Neustrelitz's palatial park have been preserved. They were chiselled from sandstone

in the second half of the 18th century by two unknown artists and portray ancient gods and allegorical figures.

Below right:

At the intersection of the main garden axis and the avenue of temples in the park of Schloss Neustrelitz stands the Temple of

Hebe containing a copy of Antonio Canova's famous statue of the goddess of youth and this ornate ceiling.

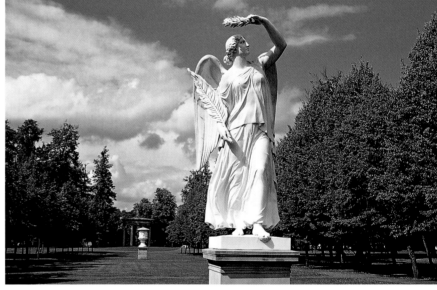

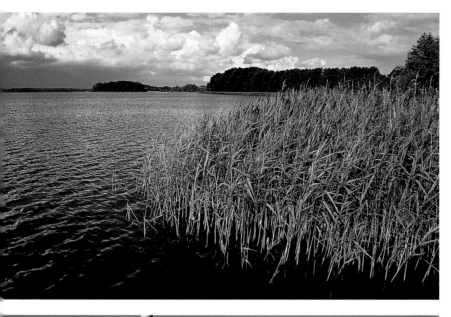

Above left:
Lake Userin, lying to the east of Neustrelitz and west of Lake Müritz, is part of the large labyrinth of waters called the Mecklenburg Lakeland, which attracts many summer guests.

Centre left:
The little town of Waren was transformed to an important hub of three Mecklenburg railway lines in the short period between 1879 and 1886. Today, the new marina – here in a view from across Lake Müritz – links the routes of yacht enthusiasts as well.

Below left:
Lake Müritz not only forms the middle point of the largest linked lake region in Central Europe, but of the national park bearing its name as well. It and the other waters of the Mecklenburg Lakeland in a row offer approximately 2,000 kilometres (1,240 miles) of navigable waterways.

Below:
On the Grosse Labussee to the southeast of Lake Müritz. Once you have made it this far, you ought to journey to nearby Mirow, where the dukes of Mecklenburg-Strelitz commissioned Christoph Julius Löwe, designer of the palace of Neustrelitz, with a remarkable summer residence.

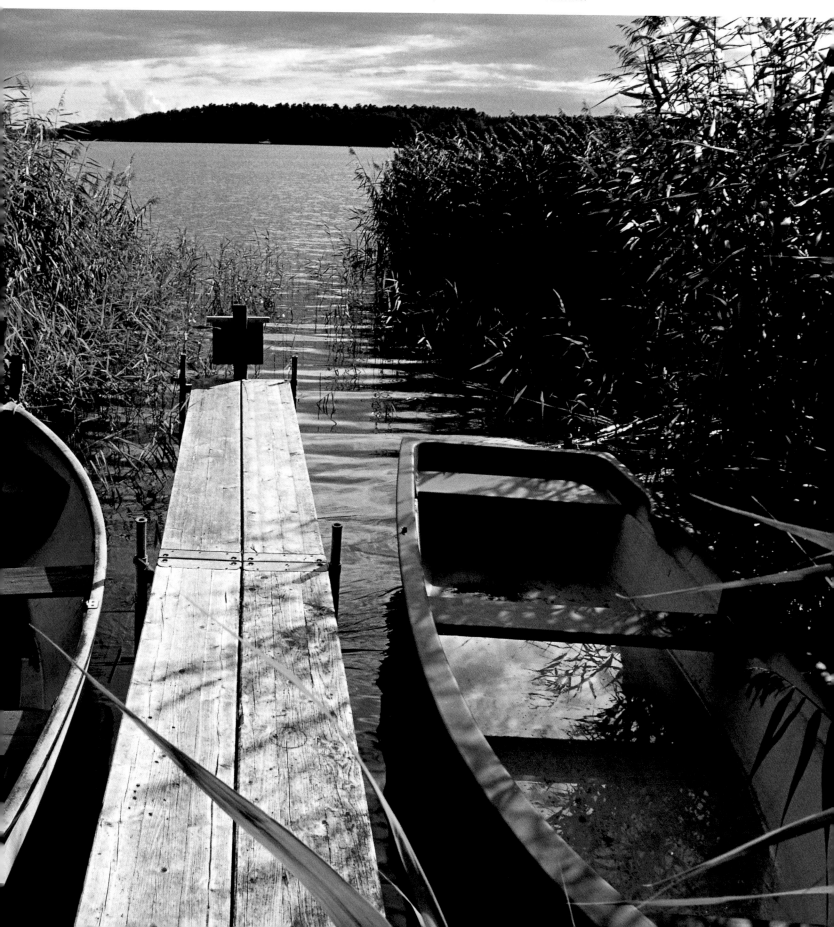

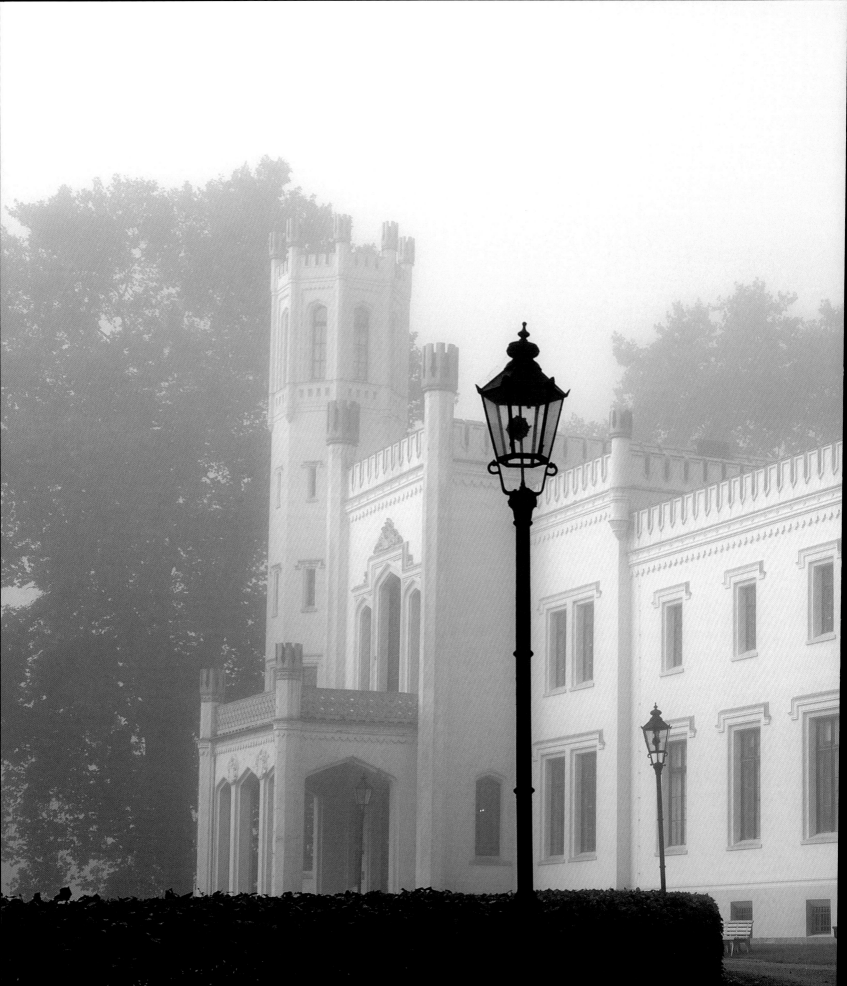

Left:
In the early light of dawn, when the morning fog still lingers, Schloss Kittendorf seems eerie and almost ethereal, with its contours only slowly emerging from the gloom. The palace was built under Hans Friedrich von Oertzen, with the architect applying English mock Tudor to the north of Germany. Landscaping wizard Peter Joseph Lenné was also commissioned to work his particular form of magic on the surrounding gardens.

Above:
Between 1993 and 1995 Schloss Kittendorf was renovated in the style of the day and reborn as a luxury hotel. The palace restaurant smacks of style, panache and exclusive cuisine.

Pages 118/119:
Schloss Basedow east of Malchin was erected on a medieval fortress site in the 16th century and repeatedly renovated and expanded until the 19th century. Today it is a hotel. Its park was designed in the style of an English garden by Peter Joseph Lenné.

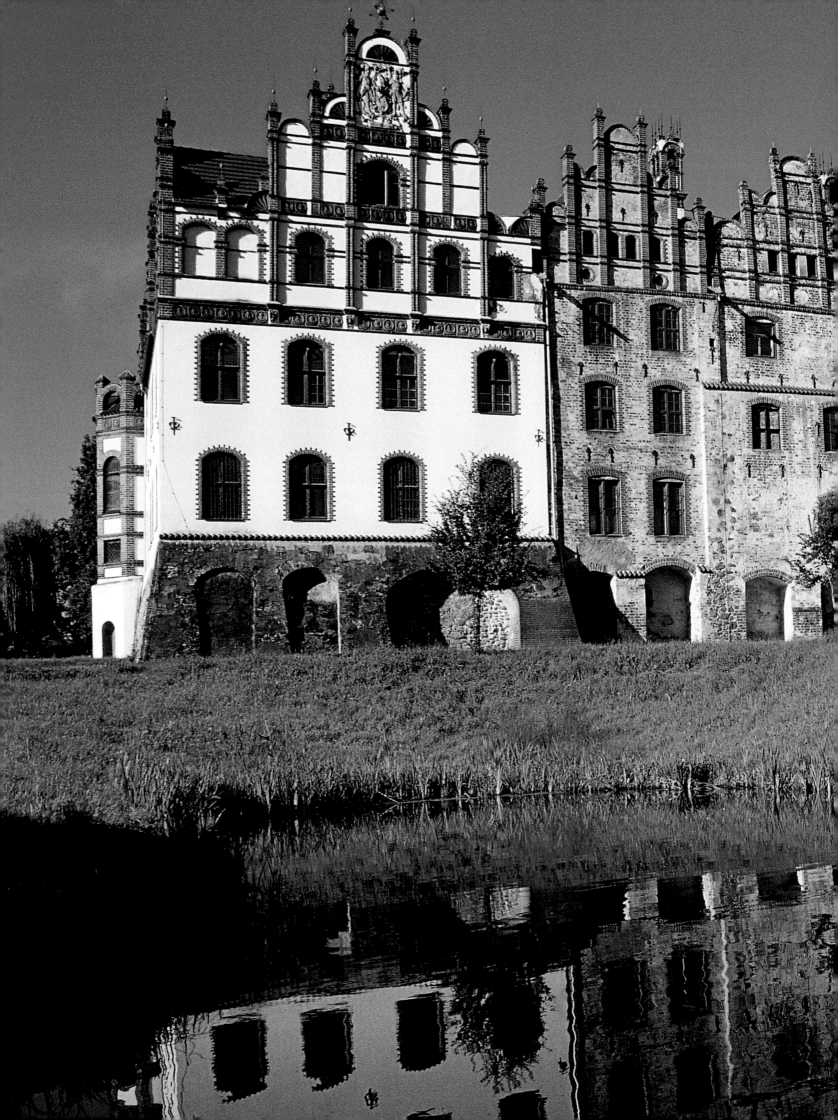

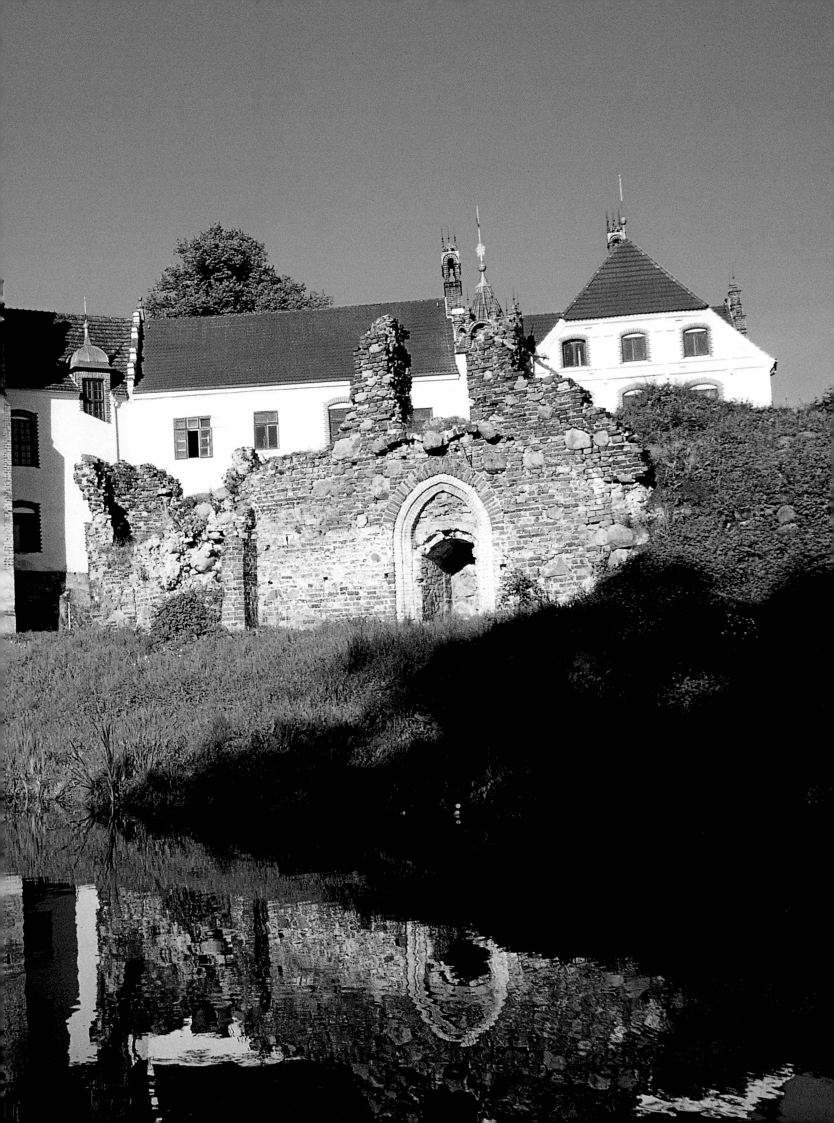

Below:
A tree-lined "Allee" near
Malchin, from which the
"mountains" are not far.
They are not much higher
than hills; nevertheless,
they are called Mecklen-
burg's Switzerland.

**Right page,
above and below:**
The fields in the coun-
tryside around Malchin
appear endless. Major
parts of them were owned
by the Hahn family, one of
the most important noble
families of Mecklenburg.

In the late 18th centu.
Count Friedrich von Ho
had the region's fi
observatory built and .
son was a great patror.
the German theat

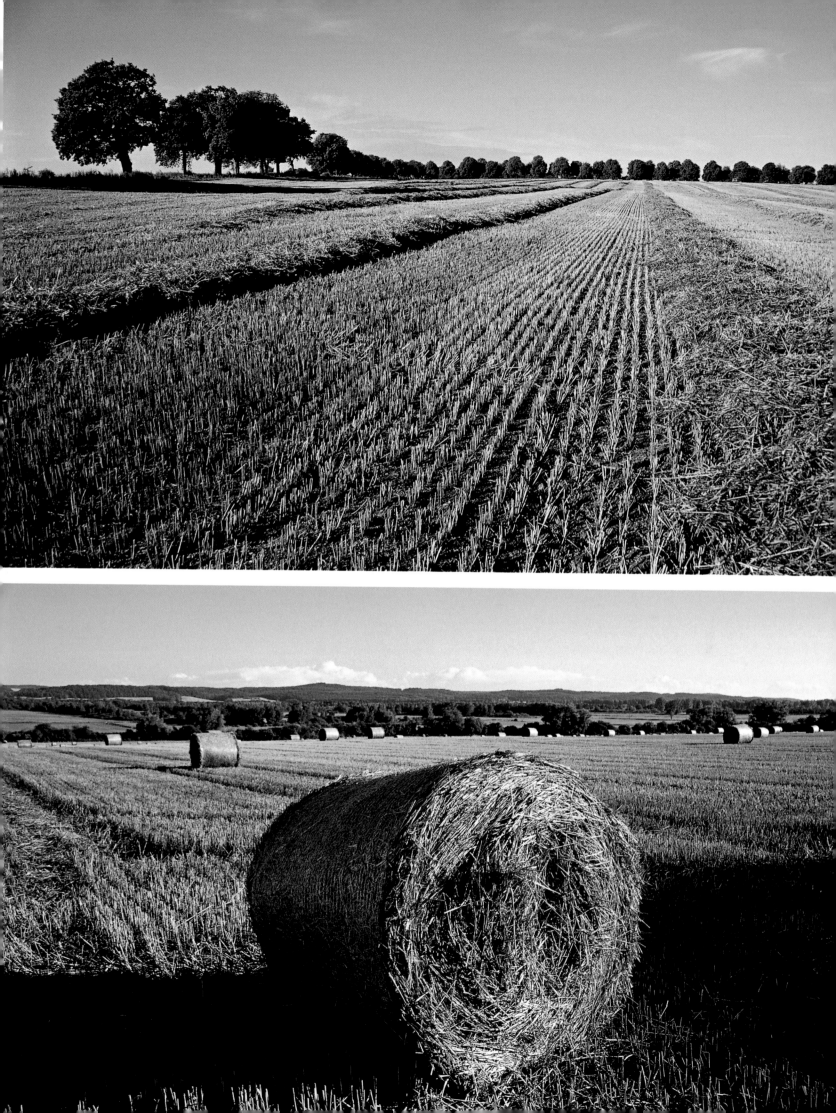

In addition to interesting brick structures, on a stroll through Parchim you will also encounter a number of handsome half-timbered houses, some of which date from the 16th and 17th centuries.

The idyllic little town of Parchim surrounded by forests to the south-east of Schwerin was first mentioned in a document dating from 1170. Six hundred years later, Prussian Field Marshall Count Helmuth von Moltke first saw the light of day here.

Above:
As the façade of the entrance still clearly shows, the town hall of Parchim was built in Gothic times. At the beginning of the 19th century, it was renovated by Johann Georg Barca to be the seat of the Supreme Court of the two Grand Duchies of Mecklenburg.

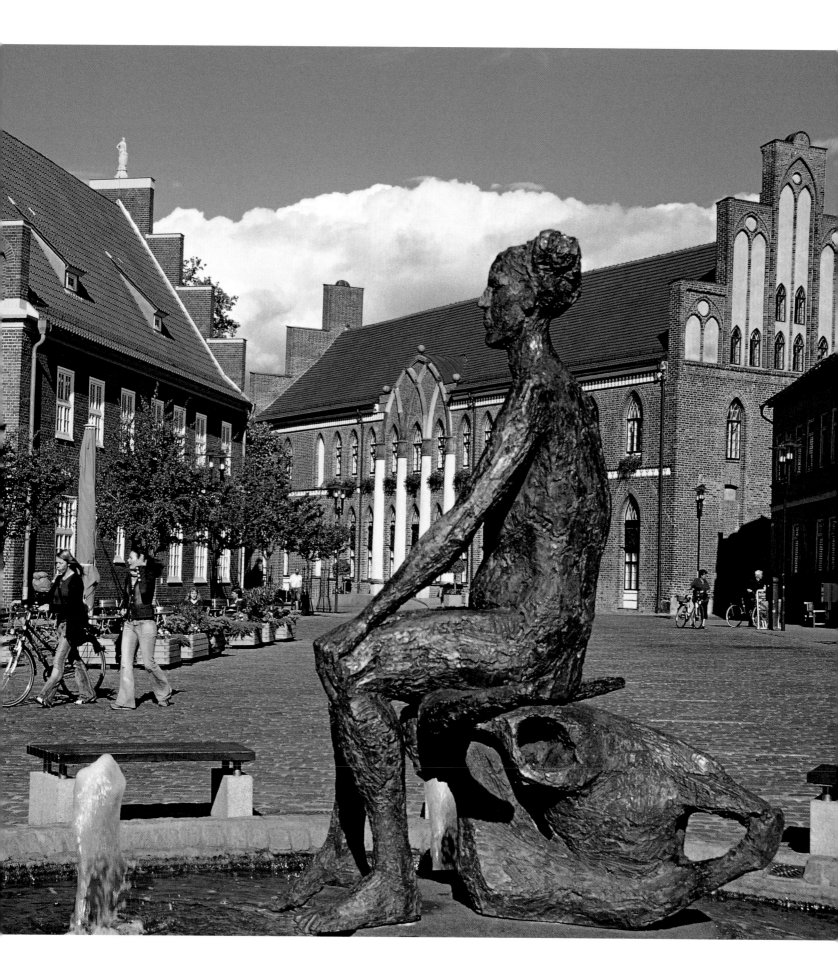

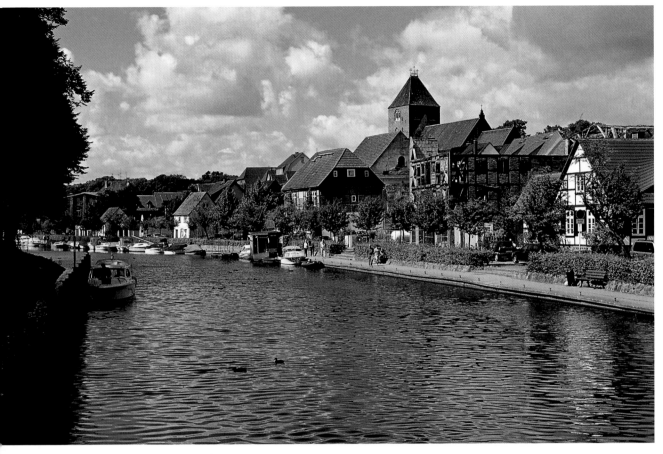

Left page:
Many quiet spots can be found on Lake Dobbertin, northeast of Parchim in the Nossentiner-Schwinzer-Heide Nature Park.

Idyllic small town by the water. Plau am See, which was granted a town charter in 1235, grew from the Slavic settlement of Plawe. All that remains of the medieval castle is its high tower. Water sports enthusiasts appreciate the convenient location of the town on Lake Plau and on the Elde-Müritz water route.

In 1220, a Benedictine monastery was built on the northern shore of Lake Dobbertin. The brick monastery church dates from the 14th century. In the first half of the 19th century, it was given a stone Gothic Revival shell designed by Karl Friedrich Schinkel.

Below:
Some of the houses in Plau
am See were erected after
the great fire of 1758, how-
ever the town hall was not
built until 1888/89 in the
Neo-Renaissance style. The
town's oldest surviving
structure is the brick Gothic
town church.

Right:
Although many parts of it
were torn down when the
line of Güstrow dukes died
out, Güstrower Schloss
is Mecklenburg's largest
preserved secular structure
from the Renaissance.
testifies to Italian as well
as Dutch and German influ-
ences. After long, expensiv
restorations, the interi
rooms are now used as
museu

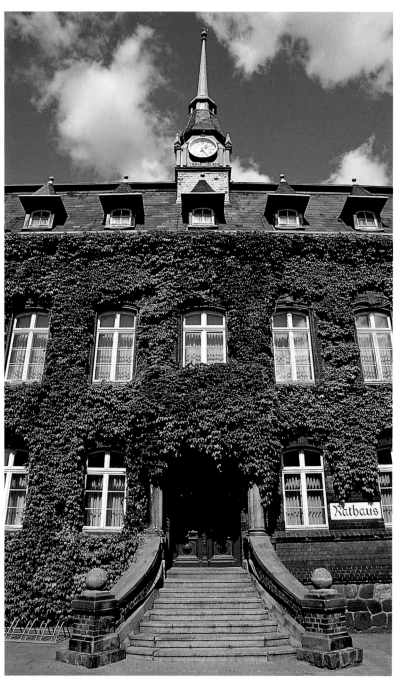

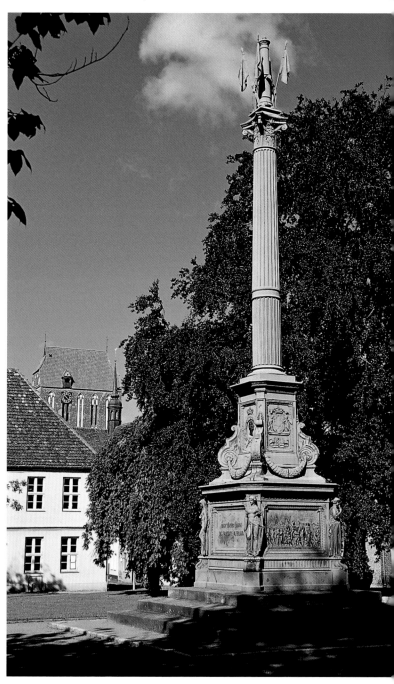

Above:
Güstrow's historic
buildings and monuments
give visitors interesting
insights into the history
and cultural past of this
city, which was the seat of
the dukes of Mecklenburg-
Güstrow from 1556.

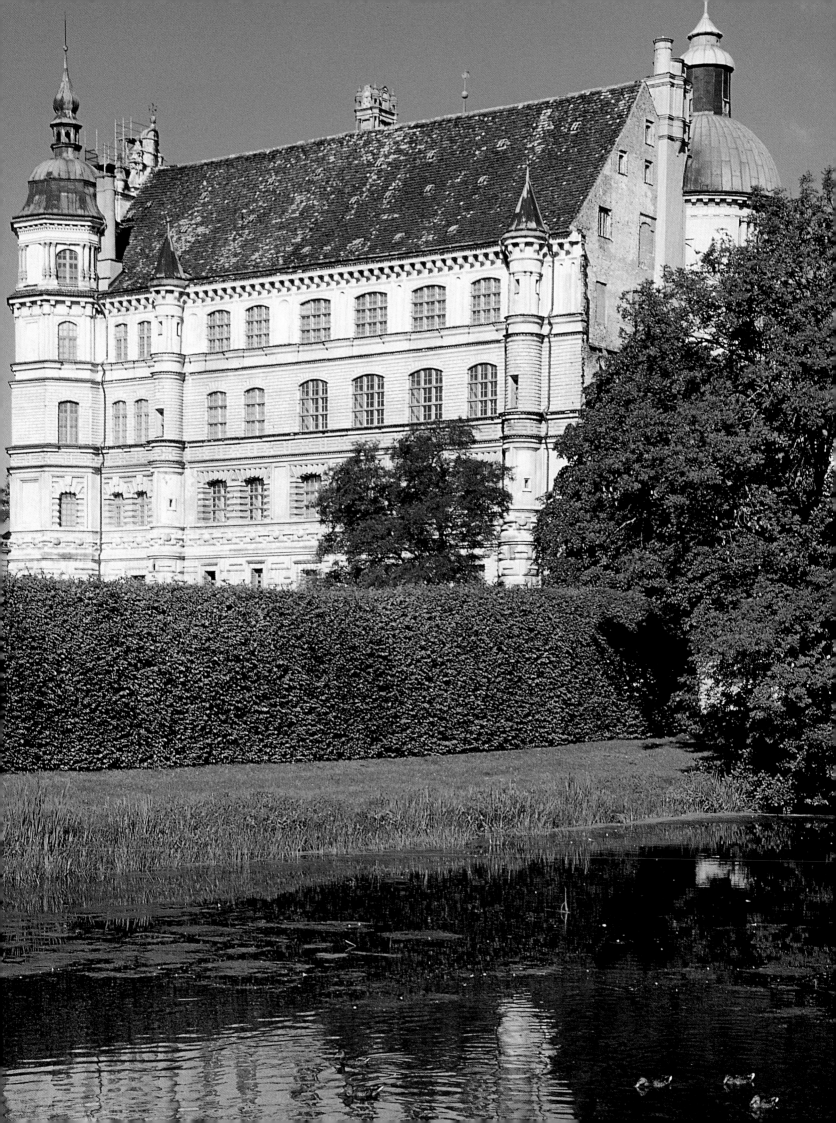

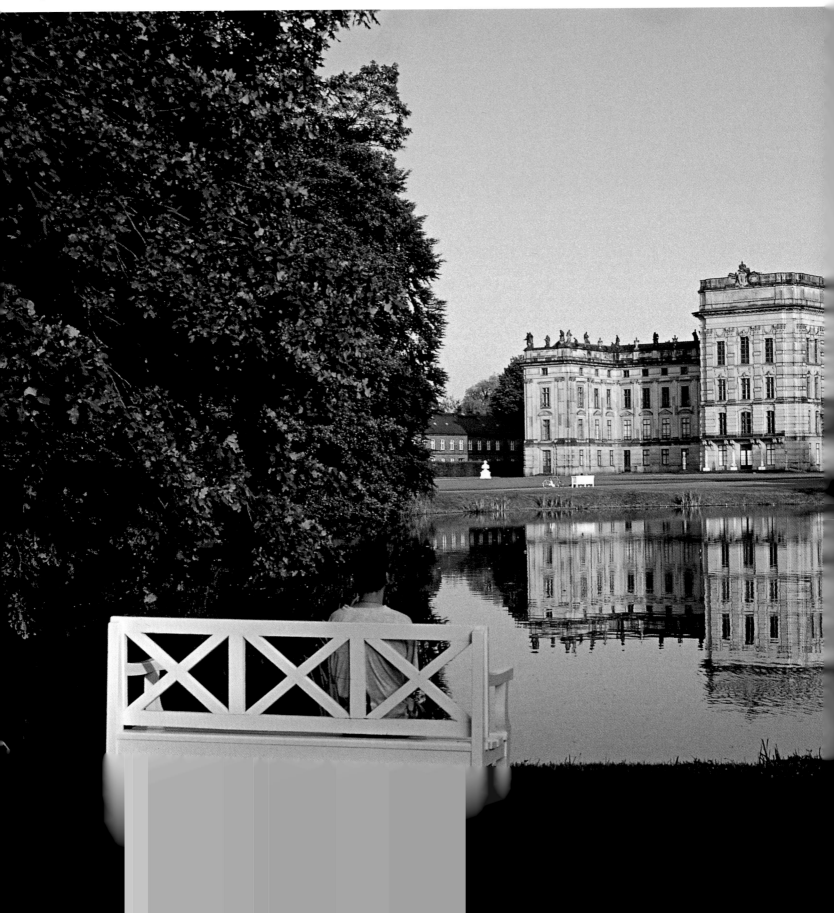

Below:
In the middle of the "Griesen Gegend" or "dry region", once the poorest corner of the entire duchy of Mecklenburg-Schwerin, we find one of the most magnificent palaces – to which a splendid park and entire town were added. With Ludwigslust – named after his father's simple predecessor house – Duke Friedrich realized his dream of a Mecklenburg Versailles.

Above right:
The palace gardens at Ludwigslust were first designed in the Baroque style and later transformed into an English garden by Peter Joseph Lenné. The fountains and cascades, which are fed by a 28-kilo-metre (17.4-mile) long canal, are among its highlights.

Centre right:
Schlossstrasse number 14 in Ludwigslust. The former village street of the small town of Klenow, which gave way to the new town,

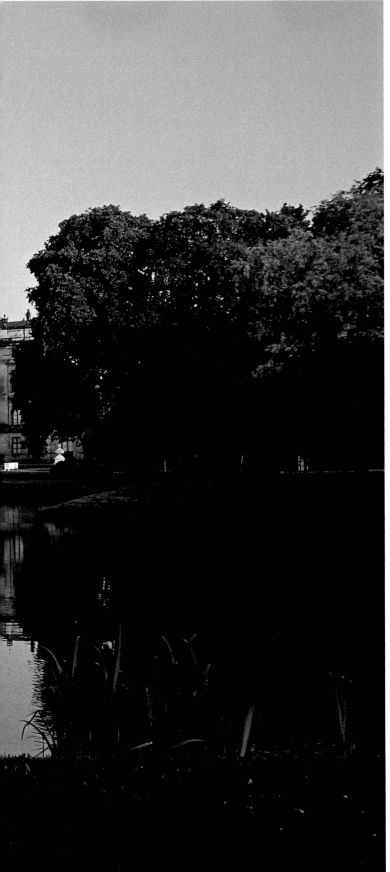

…gether with Alexandrinen-platz became the magis-…rial seat of "Lulu", as the inhabitants fondly nick-name their town.

Below right:
Besides its chief task of serving the desires of Duke Friedrich and his court, the new town of Ludwigslust also required administration. Across from the palace, one of the most important Baroque structures of Mecklenburg-Western Pomerania, the town hall appears rather modest and plain.

129

Below:
After abdicating in 1918,
the Grand Duke continued
to reside in the palace of
Ludwigslust until 1945. It
became the administrative
seat during GDR times.
Later, long and costly
restorations were required
before the palace museum
opened its doors to the
public.

Right:
The setting for the splendid
feasts in Schloss Ludwigs-
lust was the Golden Hall,
which measures 300 square
metres (3,229 square feet).
Its surrounding gallery and

the ceiling are carried
grand Corinthian column.
The golden surface of t.
décor masks the und
layer, which was ma
mainly of cheap papie
mâch

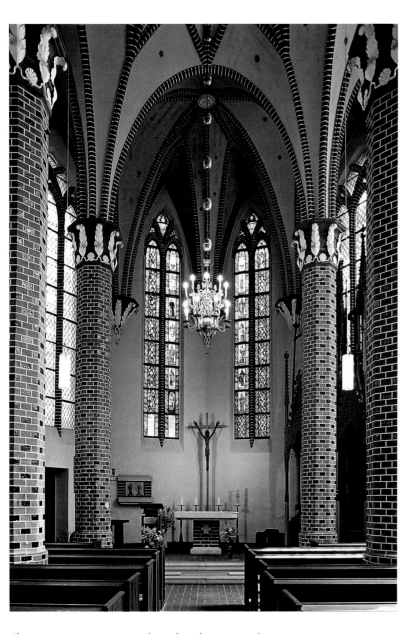

Above:
Ludwigslust has a
Protestant town church as
well as the Catholic church
of St Helena. It was erected
on an artificial island in

the early 19th century and
was the first house of
worship in Mecklenburg to
be built in the later
popular Gothic Revival
style.

Right:
The museum in Schloss
Ludwigslust reveals
interesting glimpses into
courtly living and art of

the 18th and 19th centurie
The historic rooms ar
the park are used for co.
certs and festivals as we

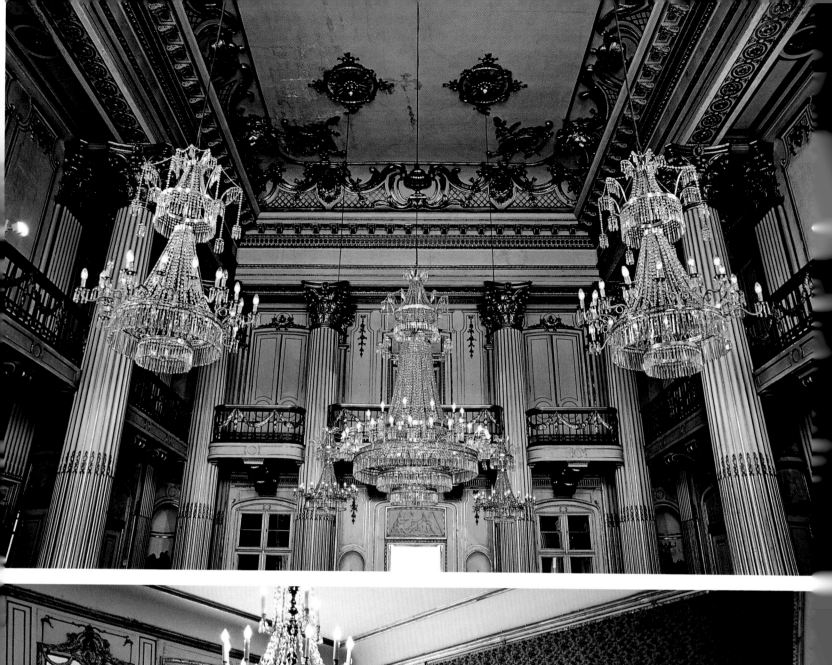
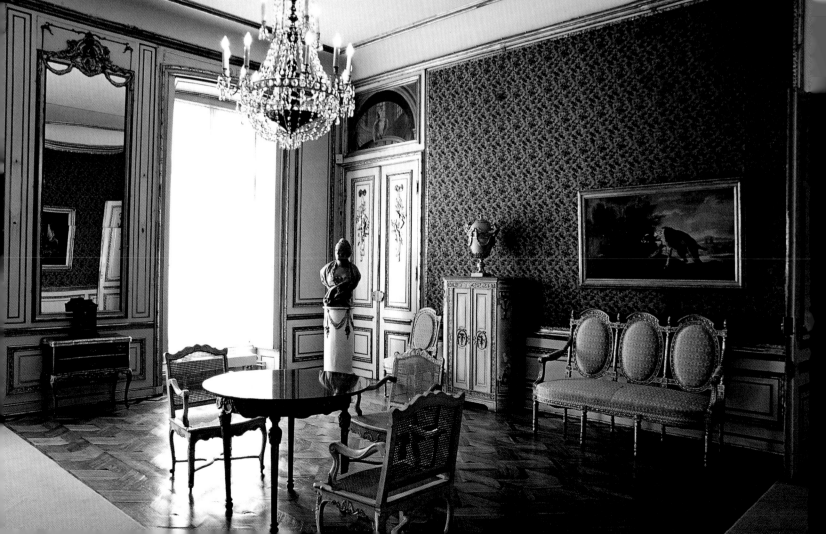

On the Ivenacker See near Stavenhagen. Fritz Reuter, who lived here, paid sympathetic yet critical homage to the people and scenery of his homeland in his work. In a positive vein, he was once moved to say of the region that it was "the dearest thing I knew on earth".

Schloss Ivenack was built at the end of the 16th century on the foundations of an old Cistercian monastery which was dissolved in 1555, three hundred years after its founding. The palace was remodelled several times before it finally received its present Neo-Renaissance getup.

Right page:
The oaks in Ivenack are said to be the oldest in Germany, dating back about 1,000 years. Originally there were eleven of these giants; now there are just six. Despite their reduced number, they still serve to remind us of how transitory our lives are.

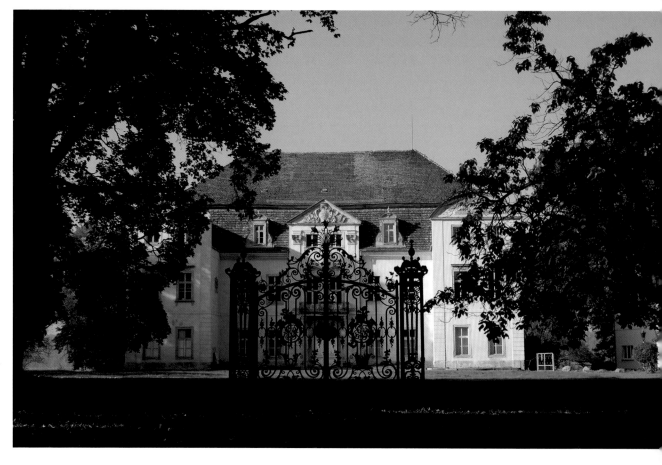

INDEX

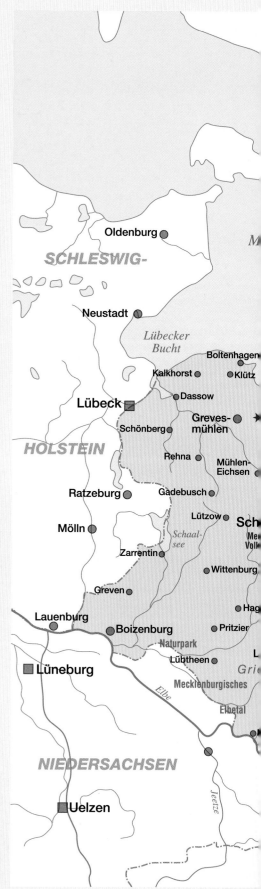

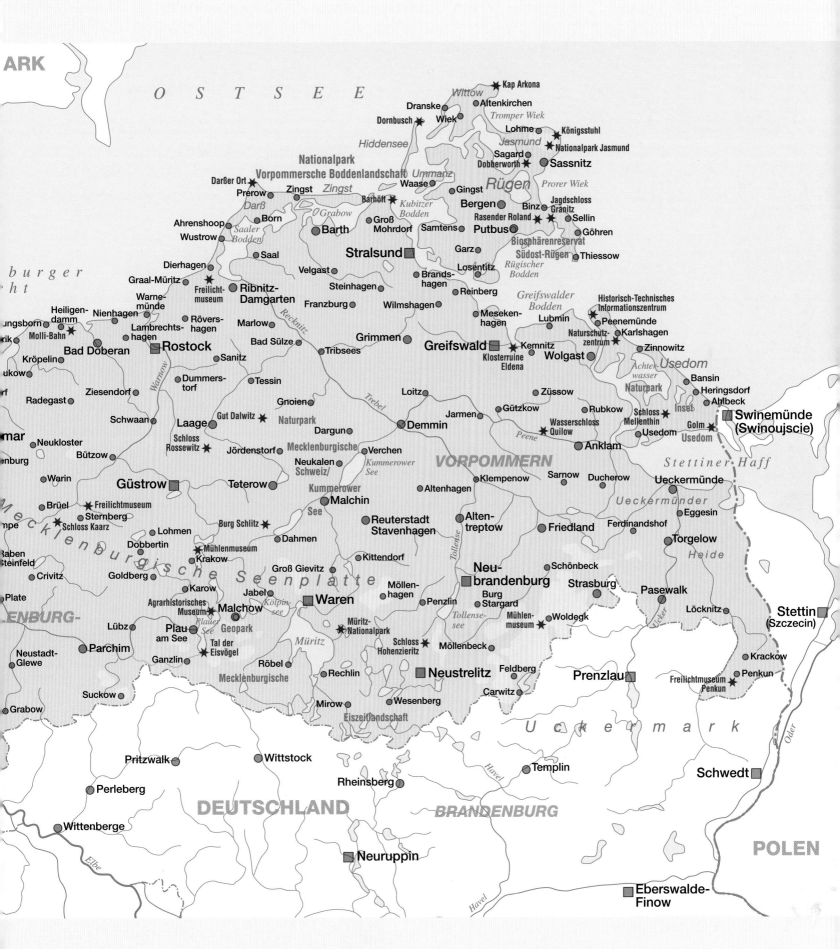

OSTSEE

DÄNEMARK

Wittow
Kap Arkona
Dranske
Altenkirchen
Tromper Wiek
Dornbusch
Wiek
Lohme
Königsstuhl
Jasmund
Nationalpark Jasmund
Hiddensee
Sagard
Dobbeworth
Sassnitz
Nationalpark
Vorpommersche Boddenlandschaft
Ummanz
Rügen
Prorer Wiek
Darßer Ort
Zingst
Zingst
Waase
Gingst
Bergen
Prerow
Barhöft
Kubitzer
Bodden
Binz
Jagdschloss
Granitz
Darß
Born
Grabow
Groß
Mohrdorf
Rasender Roland
Sellin
Ahrenshoop
Saaler
Barth
Putbus
Göhren
Wustrow
Bodden
Samtens
Biosphärenreservat
Saal
Garz
Südost-Rügen
Thiessow
Dierhagen
Stralsund
Losentitz
Rügischer
Bodden
Graal-Müritz
Velgast
Brands-
hagen
Freilicht-
Ribnitz-
Steinhagen
Greifswalder
Heiligen-
museum
Damgarten
Franzburg
Wilmshagen
Reinberg
Bodden
Historisch-Technisches
damm
Warne-
Nienhagen
Rövers-
Marlow
Meseken-
Informationszentrum
Bansin
münde
hagen
hagen
Lubmin
Peenemünde
Lambrechts-
Bad Sülze
Grimmen
Greifswald
Naturschutz-
Karlshagen
Heringsdorf
Molli-Bahn
hagen
Rostock
Kemnitz
zentrum
Ahlbeck
Bad Doberan
Sanitz
Tribsees
Klosterruine
Wolgast
Zinnowitz
Kröpelin
Dummers-
Eldena
Usedom
Ziesendorf
torf
Tessin
Loitz
Züssow
Achter-
Naturpark
Radegast
Gnoien
Trebel
Jarmen
Gützkow
Rubkow
wasser
Inse
Schwaan
Gut Dalwitz
Naturpark
Dargun
Demmin
Peene
Wasserschloss
Schloss
Quilow
Usedom
Golm
Swinemünde
Laage
Mellenthin
Usedom
(Swinoujscie)
Schloss
Jördenstorf
Mecklenburgische
Verchen
Anklam
Rossewitz
Teterow
Neukalen
Kummerower
Klempenow
Sarnow
Ducherow
Stettiner Haff
Güstrow
Schweiz/
See
Uckermünde
Brüel
Freilichtmuseum
Kummerower
Altenhagen
Ueckermünder
Sternberg
Malchin
See
Reuterstadt
Alten-
Eggesin
Schloss Kaarz
Burg Schlitz
Stavenhagen
treptow
Friedland
Ferdinandshof
Lohmen
Dahmen
Neu-
Torgelow
Dobbertin
Mühlenmuseum
Kittendorf
brandenburg
Strasburg
Heide
Crivitz
Krakow
Groß Gievitz
Schönbeck
Pasewalk
Goldberg
Karow
Jabel
Möllen-
Burg
Plate
Agrarhistorisches
Kölpin-
Waren
hagen
Penzlin
Stargard
Mühlen-
Löcknitz
Stettin
Museum
Malchow
see
Tollense-
museum
(Szczecin)
Lübz
Plau
Müritz-
see
Woldegk
Krackow
am See
Nationalpark
Möllenbeck
Parchim
Tal der
Geopark
Schloss
Penkun
Neustadt-
Eisvögel
Müritz
Hohenzieritz
Glewe
Ganzlin
Röbel
Neustrelitz
Freilichtmuseum
Suckow
Rechlin
Feldberg
Prenzlau
Penkun
Mirow
Carwitz
Grabow
Wesenberg
Eiszeitlandschaft
Uckermark
Oder

Pritzwalk
Wittstock
Templin
Schwedt
Rheinsberg
Perleberg
DEUTSCHLAND
BRANDENBURG
Wittenberge
Elbe
Neuruppin
Havel
POLEN
Havel
Eberswalde-
Finow

135

The island church on Hiddensee was part of the Cistercian monastery founded in 1296. The baptismal angel from 1780 floats from the ceiling inside the church.

Credits

Design
www.hoyerdesign.de

Map
Fischer Kartografie, Aichach

Translation
Faith Gibson Tegethoff, Swisttal
Ruth Chitty, Stromberg

Printed in Germany
Repro by Artilitho, Lavis-Trento, Italy – www.artilitho.com
Printed/Bound by Offizin Andersen Nexö, Leipzig
© 2009 Verlagshaus Würzburg GmbH & Co. KG
© Photos: Tina and Horst Herzig
© Text: Ernst-Otto Luthardt

ISBN 978-3-8003-4007-1

Details of our programme can be found at
www.verlagshaus.com

Photographers
Tina und Horst Herzig live in Bensheim and work as freelance photographers and designers. Among others, Verlagshaus Würzburg has published their illustrated books about France, Denmark, England and Saxony.

Author
Ernst-Otto Luthardt, born in 1948, lives and works in Franconia in Bavaria. The focal points of his work as freelance author are articles on cultrual history and texts for travel picture books. Verlagshaus Würzburg has published illustrated books by Ernst-Otto Luthardt about Bavaria, Israel, the Mazurskie Lakeland, Norway, Poland, Pomerania, Silesia and St. Petersburg.

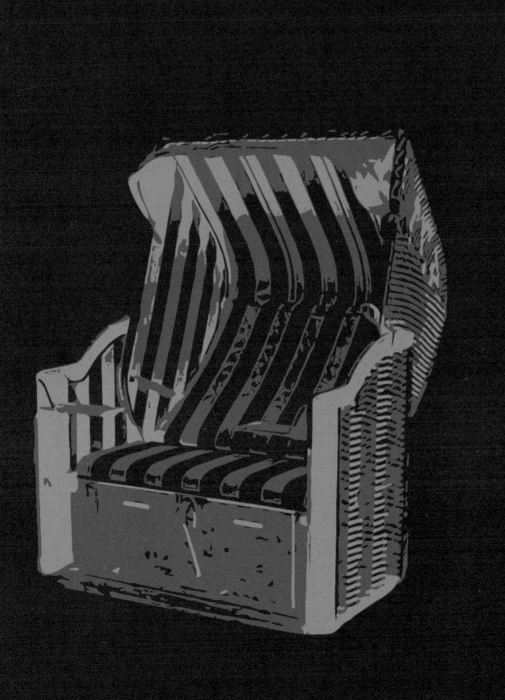